PhoDOGraphy

How to Get Great Pictures of Your Dog

by **Kim Levin**

Copyright © 2008 Kim Levin

Senior Acquisitions Editor: Abigail Wilentz
Project Editor: Carrie Cantor
Designer: Verde and Verde Communication
Art Director: Timothy Hsu
Production Manager: Salvatore Destro

First published in 2008 by Amphoto Books
an imprint of Watson-Guptill Publications
Nielsen Business Media
a division of The Nielsen Company
770 Broadway
New York, NY 10003
www.watsonguptill.com
www.amphotobooks.com

ISBN-13: 978-0-8174-2718-4
ISBN-10: 0-8174-2718-X

Library of Congress Control Number: 2008927389

Watson-Guptill Publications books are available at special discounts when purchased in bulk for premiums
and sales promotions, as well as for fund-raising or educational use. Special editions or book excerpts can be
created to specification. For details, please contact the Special Sales Director at the address above.

Printed in China

1 2 3 4 5 6 7 8 9 / 16 15 14 13 12 11 10 09 08

To my Dad, who always wanted me to be a teacher.

Hopefully this book counts!

Table of Contents

Preface

When I was first approached to write a book about taking dog portraits, it brought back memories of how I started my career in pet portraiture. Ten years ago, I began an incredible photographic journey. It started with the idea of joining my two great loves: dogs and photography. At the time, I was working in the advertising industry as an account executive in New York and, in my free hours, was taking portrait classes at the International Center for Photography. I had previously taken a few photography classes in high school and college, but, for the most part, I am self-taught.

One day, as I was walking to work—camera around my neck—I began to notice all of the dogs on the streets of the city. They walked with confidence and a sense of individuality typical of New Yorkers. I couldn't wait until I had some free time to get back outside to start taking pictures. My first portraits were of dogs roaming the streets, going for walks, playing in parks, and inhabiting the city as if it were their own.

During this time, I started a project with the Center for Animal Care and Control taking portraits of homeless dogs at the city's shelters and creating posters to promote animal adoption. I

discovered that I could use my photography to promote a cause that I felt passionate about. I realized that this was what I was meant to do.

Thus, Bark & Smile Pet Portraits® was born. Becoming a pet photographer was a natural thing for me to do. I grew up in a household full of dogs. Throughout my entire childhood, we always had two or more dogs in our family. We had a dachshund named Susie Q, a beagle named Taffy, and several Irish setters named Kelly, Magee, and Molly Malone. I grew up believing that dogs were family members. Each of our dogs had a unique personality. Molly was a sweetheart, whereas Magee was crazy and disobedient. I believe that growing up with dogs instilled in me a deep respect for animals and is the foundation for the wonderful rapport I now have with them as an adult. I have a genuine love and admiration for all dogs, and that connection is intrinsically a large part of who I am.

In my new vocation, I quickly developed a portfolio of work, focusing my energy on creating a signature look and style. This is something that is critical for every photographic artist. Find what you enjoy photographing and experiment. Take a lot of pictures, and try different techniques to see what personal style suits you.

Over the next two years, I began promoting my photography business by doing commissioned work. At the same time, I explored the various ways that I could make my living as a pet portrait artist. Many friends and relatives thought I was crazy and taking too much of a risk when I decided to leave my job in advertising and pursue my passion, but I knew it was my calling. It took a few years, but eventually my goal of combining my love of photography and dogs paid off. I have been taking pet portraits ever since. In 1998, I published my first book, titled *Why We Love Dogs*.

My photographic style has evolved over the past ten years, but the one constant has been my reliance on my instincts when photographing animals. For example, I know that a trusting dog will lie on its back and allow you to rub its belly, whereas a more timid dog may not. I always approach a dog slowly to determine if she is trusting and friendly. If she is, I will lie down and rub her belly while taking her picture at the same time. If I am photographing a more timid dog, I take more time to earn his trust. I don't jump right in and try to roll him on his back. I massage his ears and head while speaking softly. Once I have earned his trust then I can be more assertive while photographing him.

Having a rapport with dogs is essential to taking good portraits of them. Making a connection with the dog is the key to being able to bring out her personality in your portrait. Because I know how to talk to dogs and make them comfortable, taking their portrait comes easy. If a dog is energetic and outgoing, I tend to be more aggressive when photographing him. I may throw the ball and play tug-of-war to capture the playful side of his personality. If a dog is more reserved and sweet, I will use a sweeter, softer approach, and talk to him while taking his portrait.

Documenting a dog's life through pet portraiture is not that much different than documenting a person's life through people portraiture. Telling stories through images is the goal of every portrait or documentary photographer, professional or amateur. When you have a vision of what you truly love, follow your heart. With a lot of hard work and commitment, you can do anything.

Acknowledgments

When I orginally thought about taking on this project, I was excited and scared at the same time. Writing a book about how to take portraits of dogs seemed liked a natural next step in my career as a pet photographer. I was confident about the photography aspect of the book, but writing an in-depth book about how I take pictures was something clse entirely and I knew that it was going to be challenging.

I am always up for a good challenge, but I couldn't have done it without the guidance and support of my editors, Abigail Wilentz and Carrie Cantor.

Thank you to John, Ian, Rachael, and Charlie for your constant love and encouragement.

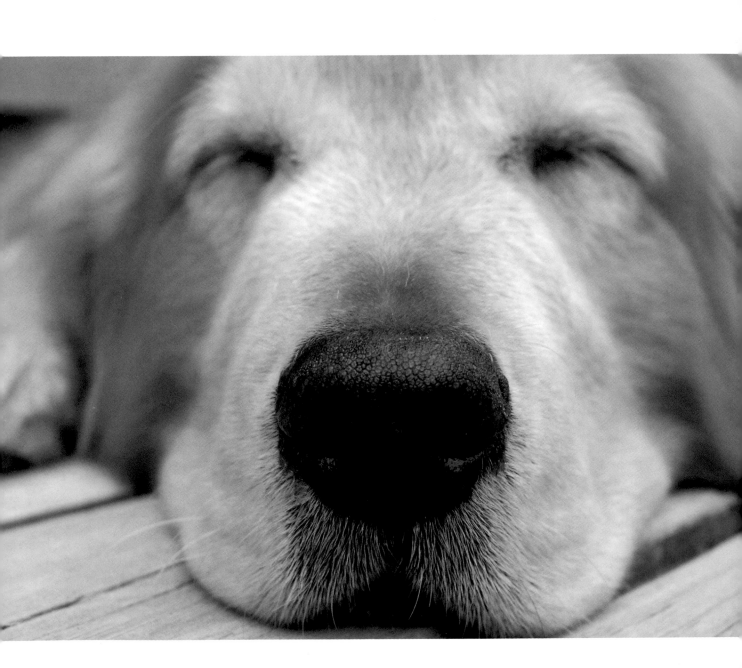

BOBBY

Introduction

Like most photographers these days, I have taken the plunge into digital photography. I was resistant at first, because I loved the look of the images from black-and-white film, and I still do. But I realized that I needed to keep up with the new technology. I have a 35mm digital SLR camera—the Nikon D200—and I love it. My camera has 12.4 megapixels, and so my images are quite sharp. I have found that it is fun and rewarding to explore the possibilities that digital photography has to offer.

There are some obvious benefits to shooting digitally. You can take many more images in one sitting without reloading and you can see what your images look like as you're shooting and edit out the weak ones. This is a great advantage, especially if you are experimenting with lighting and color. If you have a computer set up, you can view your images on the monitor while you are conducting your shoot.

Keep in mind that you need to allow quite a bit of time after your shoot to review and edit all of your images. Taking a basic Photoshop class can be invaluable, as you will learn how to crop and color-correct your images efficiently. There are many software programs available (for example, Apple's Aperture and Adobe Bridge) that have been designed to help photographers manage their workflow.

Dogs tend to move quickly, and shooting digitally allows you to capture that energy and excitement. One important thing to note, however, is that some nonprofessional digital cameras have time delays, meaning that the shot goes off about a half-second or so after you press the button. This can make dog portraiture

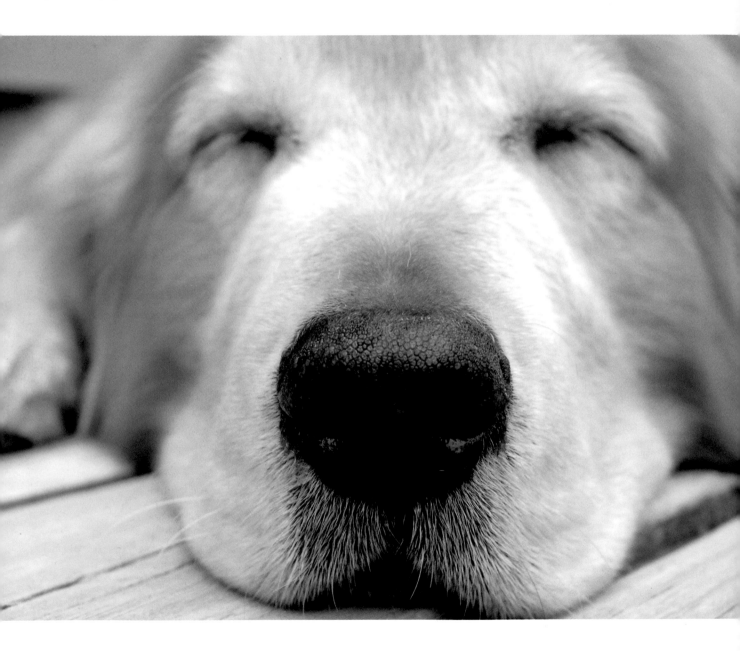

BOBBY

Tip: Get yourself a 35mm digital SLR camera and take a basic Photoshop class if you're interested in pursuing digital dog portraiture.

quite challenging and frustrating. To avoid this problem, consider getting an entry-level digital SLR 35mm (e.g., Nikon D40, Nikon D70, Canon Rebel, or EOS model). If you're serious about exploring digital photography, it's worth investing in quality equipment.

Another advantage to shooting digitally is that you can experiment with colors and textures in your final pictures. On pages x and 2 are photos of the same image in both color and black and white. The first is the original image of Bobby in color. The color image was then converted to black and white in Photoshop. I increased the contrast of the black-and-white image so that it didn't appear flat. I like both versions, but my preference is for the black and white.

There is no question that digital cameras make shooting and editing images much easier in many respects. However, there is one advantage to film that has kept me in that arena as well. I have always been a purist when it comes to black-and-white film and developing. The levels of contrast (distinctions between blacks, whites, and grays) still seem superior to me in film. This is not to say that very experienced photographers with digital darkrooms cannot convert a color file to black and white and create the same level of contrast. They can. But it takes a good darkroom and/or someone who knows how to use Photoshop well. I still enjoy shooting rolls of film, and I love the way the custom prints turn out. There's an authenticity to the film process that I cherish. Therefore, I continue to offer my clients both digital and film services.

This book will provide you with some tips on how to take great dog portraits. It is primarily for the amateur photographer who loves animals and enjoys taking pictures. However, the professional photographer may find some of the tips enlightening as well. Anyone can use these techniques to take better pictures of dogs. Happy picture-taking! ⌂

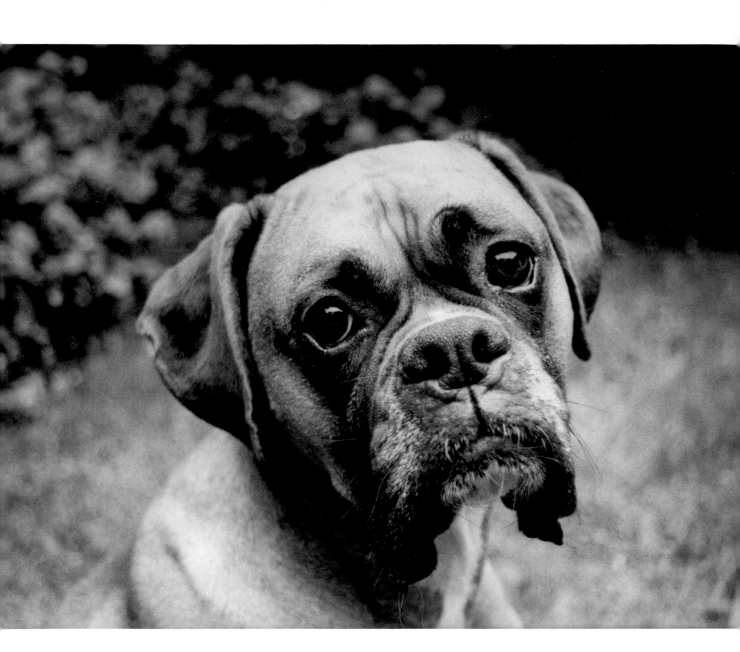

DEMPSEY

1 The Portrait

What constitutes a great portrait? You should be thinking about this question as you read through this book. I had to ponder it, too, as I was writing this book. There are so many elements that make up a good portrait—composition, emotion, color...

The one constant I look for when evaluating my work is the connection with my subject. Does the image make me feel happy or sad? Have I captured a look or feeling—something I didn't know about my subject when I was taking the picture? And do I want to keep looking at the photograph to see if there is some detail I haven't yet discovered?

The Black-and-White Portrait

When I began my career as a pet photographer, I shot exclusively in black-and-white film. I was working on developing my own signature style and was a huge fan of Elliot Erwitt and Mary Ellen Mark, two photographers whose black-and-white portraits were outstanding. I concentrated on the details that black-and-white film evoked. When I looked through the camera, I saw my subject in black and white and still do today. My film camera is a Nikon F100, and I use Kodak 400 Tri-X and Kodak 100 T-MAX film.

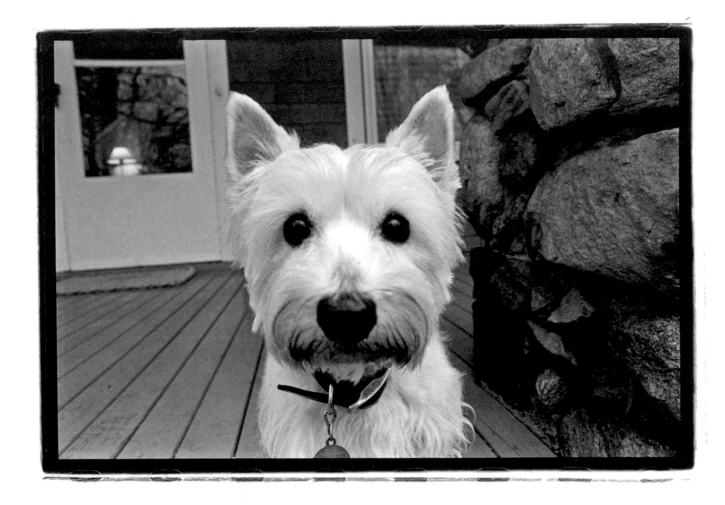

ROSIE

Black-and-white photography is classic and simple, and it's this timeless quality that has made black-and-white dog portraiture so appealing to me. Without the distraction of color, the essence of the dog's personality comes through. Is he sweet, funny, silly, graceful, peppy, mournful? All of these personality quirks are qualities that I try to capture.

The portraits of Rosie and Dempsey would not have the same effect if they were in color. This image of Rosie (opposite) was taken on her front porch after a rainstorm. The black-and-white image brings out the contrast of her white fur against the stone wall and darker background. It also highlights the light in her eyes. I feel that black-and-white imagery creates a window to the dog's soul.

The portrait of Dempsey (page 4) is a good example of how black-and-white film can bring out the smallest detail in a dog's face. Specifically, the lines around his eyes and nose give the image depth and texture. The expression on Dempsey's face is enhanced by the contrast of the film. These are characteristics that I love about black-and-white film.

Tip: When photographing in black and white, look for the details and texture in the dog's face and fur against the background, and zero in on those elements.

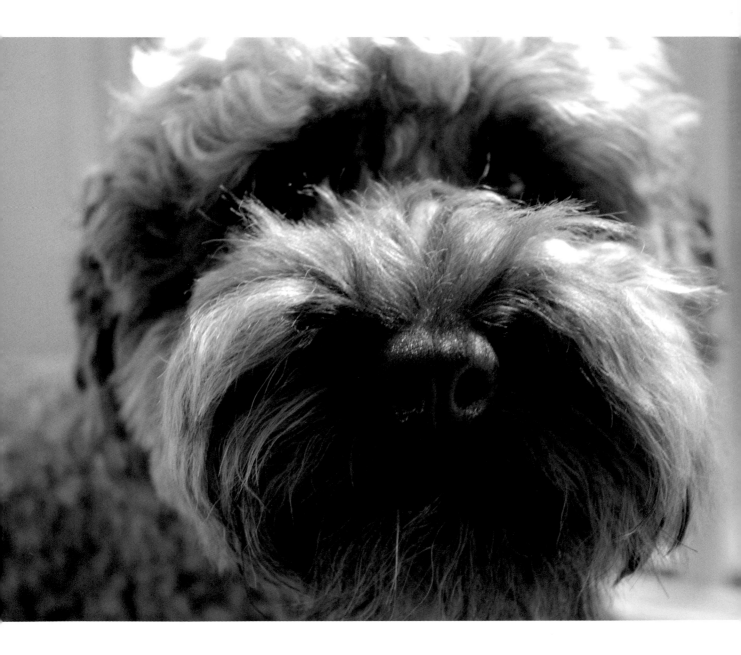

TOMMY

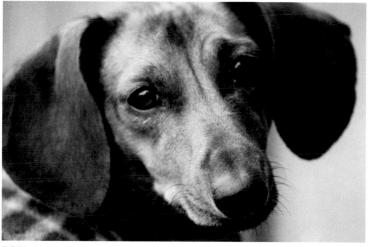

JOY

The Color Portrait

Whether you are using a film or digital camera, the approach is the same for color photography. These days, I take most of my color images with my Nikon D200 because the camera settings and the editing process allow much more flexibility than do those on my film camera. By flexibility, I am referring to the ability to adjust the exposure and colors in Photoshop. However, when I do shoot with color film, my preference is for Fuji Color Pro 400H and 160C film.

The beauty of color photography is that the resulting images closely resemble what we actually see. In animal portraiture, a dog's fur or eyes may look more vibrant in color. This is true in the portrait of Joy, a dachshund (above). You can see the distinction of the browns in her face and ears. And the way the light hits her brown eyes makes the portrait sweet and engaging. This image was taken indoors with my film camera and Fuji Color Pro 400C film.

Tip : Consider using color over black and white when photographing dogs with unique colors or unusual markings. Look at how the light illuminates the dog's fur and eyes.

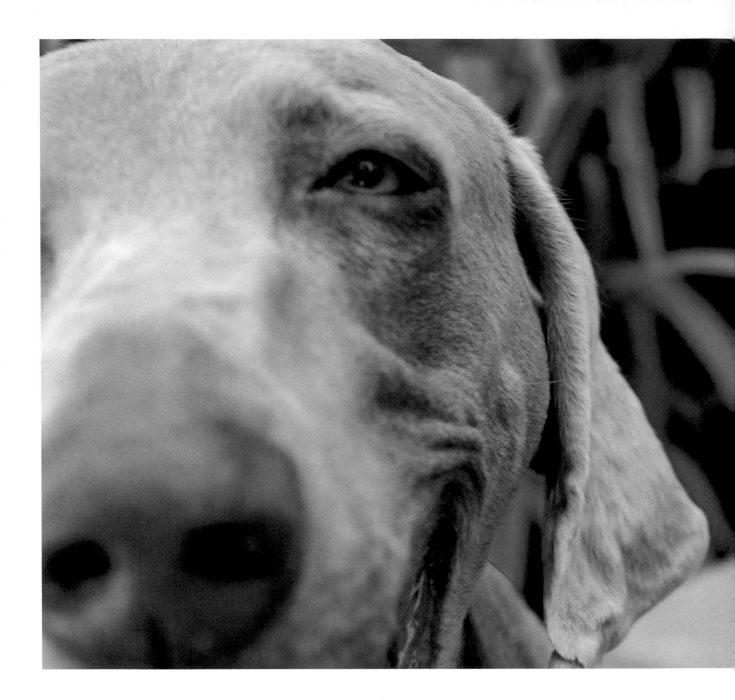

NERO

The portrait of Tommy (page 8) was also taken indoors. However, I used my Nikon D200 and placed Tommy in front of a sunlit window. This small poodle has a beautiful brown-gray coat that shimmered in the sunlight. Even though the camera is focused on his furry mouth, it is the endearing expression in his eyes that draws your attention.

The Close-up

There are several approaches you can use to take a strong close-up. I love getting close to my subject. The benefit of this approach is that it allows you to create a rapport with the dog as you're taking his picture. This will, in turn, create a more intimate and revealing portrait. Once you gain the dog's trust by rubbing his belly or talking sweetly to him, you can begin taking pictures.

The other approach is to be farther away from your subject and use a telephoto lens. This allows you to act more as an observer of the dog's world. Whereas the former approach is my preference, the latter has some benefits as well. The dog may not respond or pay attention to basic commands or he may be very excited. You may be able to capture his true nature by observing his actions and taking pictures from farther away. The purpose of a telephoto lens is to allow you to get a close-up image without intruding on your subject.

The close-up of Nero (opposite), an older dog, was taken with a Nikon D200 digital camera and wide-angle lens. Sitting right in front of Nero, who was smiling as he took a break from our photo shoot, I seized the opportunity to capture him happy and relaxed. An image of part of the dog's face can provide a glimpse into the dog's personality. Nero's portrait captures his happy and easygoing nature.

Tip: Getting close to your subject will help you create a personal relationship with the dog that will result in a more emotional and intimate portrait.

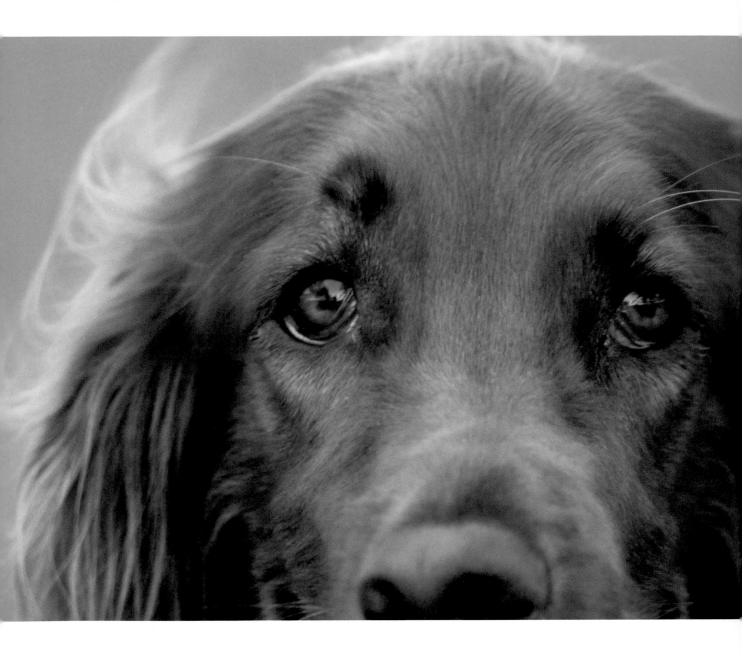

KYLIE

The portrait of Kylie, an Irish setter, (opposite) is an example of utilizing the second approach—observing the dog from afar. Kylie was playing ball in the park when her portrait was taken. I used my Nikon D200 with a 400 ISO setting and a telephoto lens because Kylie was running and jumping around. This particular image was taken as she was waiting for the ball to be thrown to her. The look in her eyes is one of intense concentration. The sunlight caught the magnificent mahogany color of her fur. You will also want to pay attention to the color and detail of your background. In this case, the vibrant green field complemented the color of Kylie's fur.

Body Parts

Zeroing in on a particular body part—eyes, nose, teeth, whiskers, ears, tail—can result in a unique and interesting portrait. In a close-up portrait, you can capture the whole dog even if you photograph only a part of him.

The Nose and Mouth

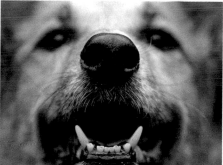

This photograph of Whitesox (left) focuses solely on his nose and mouth. Whitesox was an older dog who had his mouth open for most of our shoot. Since I couldn't get him to close it, I decided to take advantage of his excitement. I used my Nikon F100 with 400 Tri-X film, as well as my wide-angle lens. I placed myself right in front of him and opened the aperture as wide as it would go. The result is that his nose and mouth are the only areas of the photograph in focus. Even so, you still get a feeling of his carefree and youthful spirit.

When composing a close-up portrait, think about what part of the dog is most special—ears, smile, tail, body, paws? Those are the things to try to highlight in your photograph.

The Eyes

Opal, a black and tan Coonhound, has fantastic markings and gold eyes. She was photographed indoors looking out her front door. Using my Nikon D200 and 35–70mm lens, I waited for her to turn her head toward me. But she was too distracted by the noises outside the door, so I adjusted my approach with her.

I chose to highlight the intensity of her eyes and the colors of her face. The result was a close-up profile portrait (opposite, top left) that portrayed her as being much more relaxed than she really was.

The Tail

You may not have considered photographing just the tail, but such an image can provide a really different perspective on a dog. And some dogs have great tails! Tommy's was so distinctive and cute that it seemed to have its own personality. There is not a tremendous amount of technique to this picture (opposite, top right), but it is sweet and showcases a part of what makes Tommy special.

The Paws

Just like humans have unique hands, dogs have unique paws. Some are furry and large, and others dainty and distinguished. It is these features that make a dog unique.

Ben, a Bernese mountain dog, was only three months old when I took this portrait (opposite, bottom left). His paws were very large in proportion to the rest of his body. Ben was clearly going to grow to be very big, and it seemed as though his paws had beat out the rest of his body in getting to his end size. Since his paws really stood out, it seemed fitting to have them stand alone in a portrait. I took this image with my Nikon F100 and a 35–70mm lens, utilizing the "close-up" approach to zero in on his paws.

The Legs

This image of Riley's legs (opposite, bottom right) was taken with my Nikon D200 and a telephoto lens. I had been taking full-body portraits of this Weimaraner when I noticed how interesting his legs looked against the background. I wanted to accentuate how long and lean his legs were. The composition of the lines of his legs and the shadow on the lounge chair make this portrait compelling and different.

Tip: Look at each of the dog's body parts separately. Photographing part of a dog's body can be as creative as capturing the whole dog.

1. OPAL

2. TOMMY

3. BEN

4. RILEY

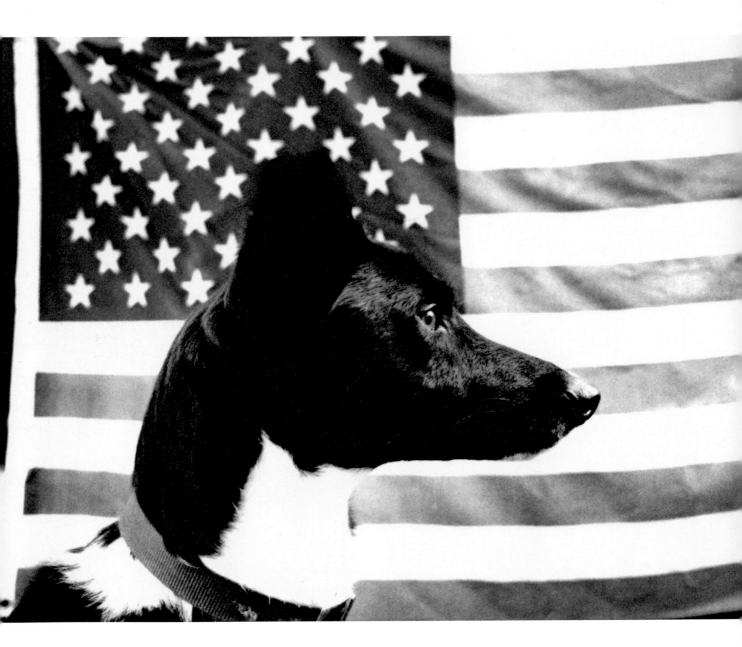

CHARLIE

The Profile

I think all dogs look good from the side. Profiles are a classic way to capture a dog's expression and personality. As a portrait technique, they also can make a dog look more stoic and serious.

This profile of Charlie in front of the American flag (opposite) was taken in the aftermath of the terrorist attacks in New York and Washington, D.C., on September 11, 2001. Even though Charlie didn't know about the country's sadness, his serious and proud expression makes you think he does. The contrast of Charlie's black face against the white stripes of the flag makes his profile stand out. I took this image with my Nikon F100 and 400 Tri-X film. I used a wide-angle lens because I wanted the flag to be as important an element in my picture as was Charlie.

In my experience, taking a profile of a dog tends to be easier than taking a photograph of a dog looking right at the camera. Dogs hear and react to noises, especially when they're outdoors, so you may find it easier to get a good profile shot when out of the house.

Tip: Profiles tend to make dogs look more serious, so you should determine whether that is in keeping with your subject's personality.

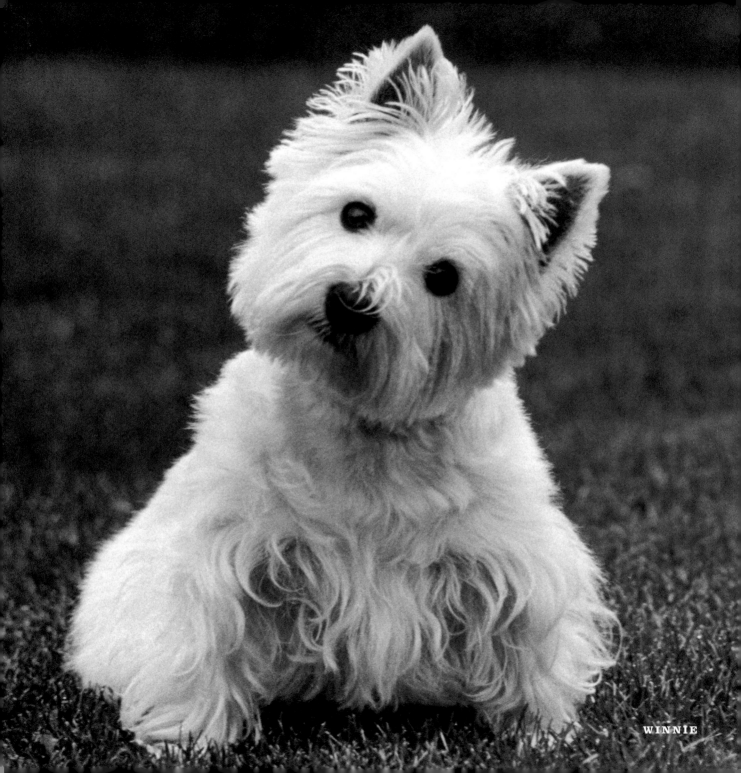

WINNIE

The Full-Body Shot

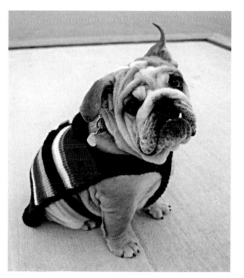

OLIVER

The full body portrait is probably the most popular type of dog portrait, so I am always looking for ways to make it more original. Winnie, a West Highland Terrier, was one of the sweetest dogs I have ever photographed. She had the cutest little body and a beautiful white coat. And she had plenty of personality, too.

I took this image of Winnie (opposite) using my Nikon F100, 125 plus-X film and a telephoto lens. I normally do not use the telephoto lens because I like getting close to my subject. However, Winnie was waiting for me to return to her backyard, and, when I did, she was sitting so perfectly that I couldn't take the chance of missing this shot. She was one of those dogs that perked right up when her name was called. When I realized that I had her attention, I zoomed in and took this shot.

Oliver, a four-month-old English bulldog, was modeling a line of doggie sweaters, and the location of the shoot was a local park with the river in the background. Because Oliver was curious about everything, it wasn't hard for me to get his attention. Then, as luck would have it, the wind blew his ear up just as I clicked the shutter. The effect added charm and humor to his portrait. This image of him (left) was taken with my Nikon F100 and Fuji Color Pro 400H film. I used a wide-angle lens because I wanted to capture his whole body against the backdrop of the platform.

Tip: Experiment with different camera lenses (wide-angle, telephoto) when taking full-body portraits. A different lens can make the ordinary full-body portrait more unusual.

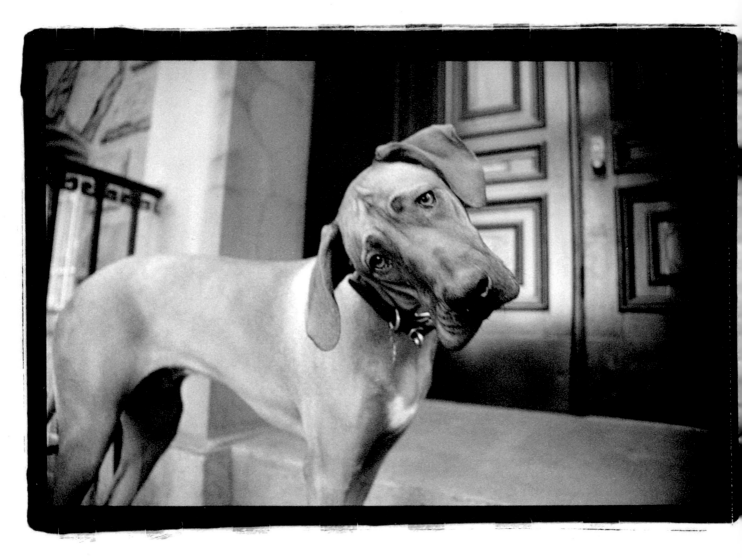

FRANKLIN

The Head Tilt

The classic head tilt is still one of my favorite kinds of portraits, and I am always looking for ways to make it more interesting and original.

When people view the portrait of Franklin (opposite), they almost always ask me, "How did you get the dog to tilt his head like that.

My response: "A harmonica!"

I first discovered the benefits of a harmonica to get a dog's attention when I met my husband, a musician. He had several harmonicas that were lying around our house. I had always used my voice to get a dog to tilt its head. However, once I tried the harmonica, I quickly learned that the high-pitched sound was a more effective way to get a dog to tilt its head. Over the years, I became adept at getting sounds out of the instrument without using my hands, as I needed those to hold the camera.

This portrait of Franklin, a Rhodesian ridgeback, was taken on the steps of his family's brownstone in New York City. He was quite curious about my harmonica and the noise it was making. I like how his listening to the odd sounds brought out Franklin's qualities of friendliness and expressiveness.

Unfortunately, the harmonica does not work on every dog. Older dogs and hyper dogs tend not to respond to it. However, they might be induced to tilt their heads in response to high-pitched noises made by the voice or simply to familiar words, such as their name.

Tip: Get out your instruments and start playing! Musical instruments, such as harmonicas, or high-pitched sounds that you can make with your voice will often cause dogs to tilt their heads.

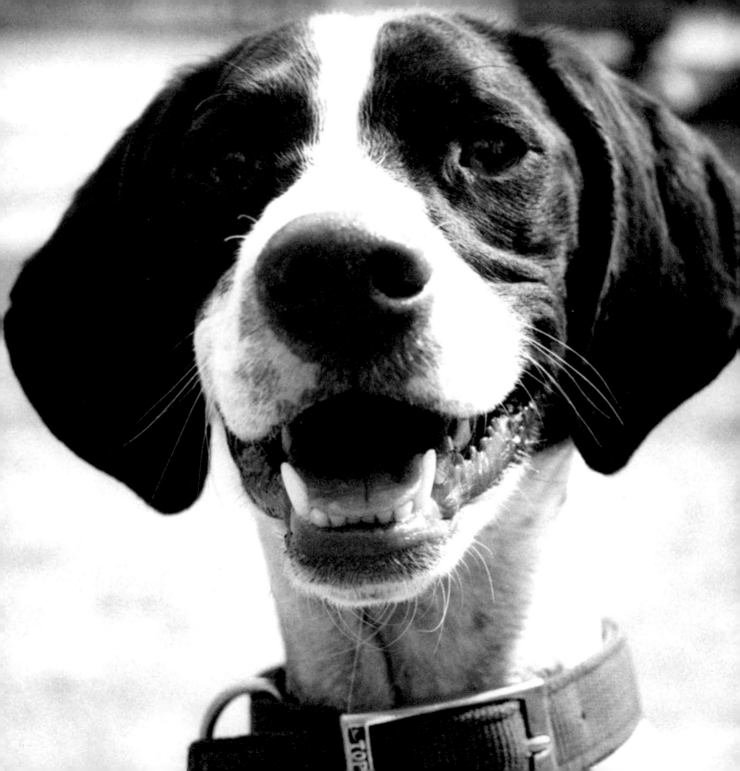

2 Capturing a Moment

I have always believed that the key to taking good pet portraits is capturing a moment that expresses emotion or evokes a feeling. It can be a moment between two dogs or a moment in the relationship between dog and owner. Or it can simply be a moment of happiness or sadness with one dog.

How do you ensure that you have the ability to capture a moment through the lens of your camera? This is something that is hard to teach because it relies heavily on instinct and experience. It is less about camera technique and more about cultivating a "good eye." Having a "good eye" for photography is analogous to a having a "good ear" for music. It's an ability to see the potential for a great photograph prior to composing the shot through the camera. You may be in a big crowd and see a moment happen that would make a great image. Or you may be looking at a simple landscape but see something within that landscape that makes an interesting photograph. The big question Is, can you teach someone to have a "good eye"? While I believe this is an innate quality that some people are lucky to be born with, I also believe that, with practice,

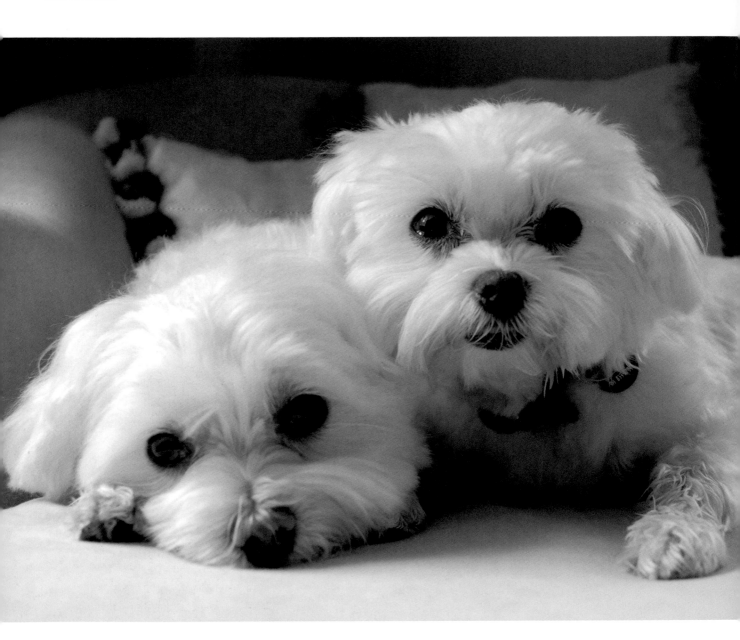

LEO AND ROCCO

anyone can learn to use their camera in a way that captures important moments and emotions.

It starts with training your eye to notice what's happening in front of you. Whether you are shooting with a digital or film camera, you may want to consider setting your camera on its automatic setting. This will allow you to concentrate on your subject and its environment.

The image of Sadie (page 22) illustrates how to capture a moment. I was at a park photographing numerous dogs, when Sadie jumped up on me and placed her front legs on my shoulders. I leaned back with my camera and snapped the shot. I used my Nikon N90 and 400 Tri-X film with a wide-angle lens. This portrait was never planned. It was the result of good timing, instinct, and an eye for noticing that what was happening would make a great image. What made the photograph effective was the moment it captured and what it said about the dog. Even though this image was taken over ten years ago, I still feel Sadie's happiness and excitement every time I look at the picture.

Between Two Dogs

When photographing two dogs it is always my goal to portray their relationship together. This image of Leo and Rocco (opposite) was taken indoors with my Nikon D200, 18–70mm lens, and a 400 ISO setting. The two dogs were constant companions; therefore, it made perfect sense to photograph them with each other. We were outdoors for most of our shoot, and when we came inside they flopped right on the couch together and began to fall asleep.

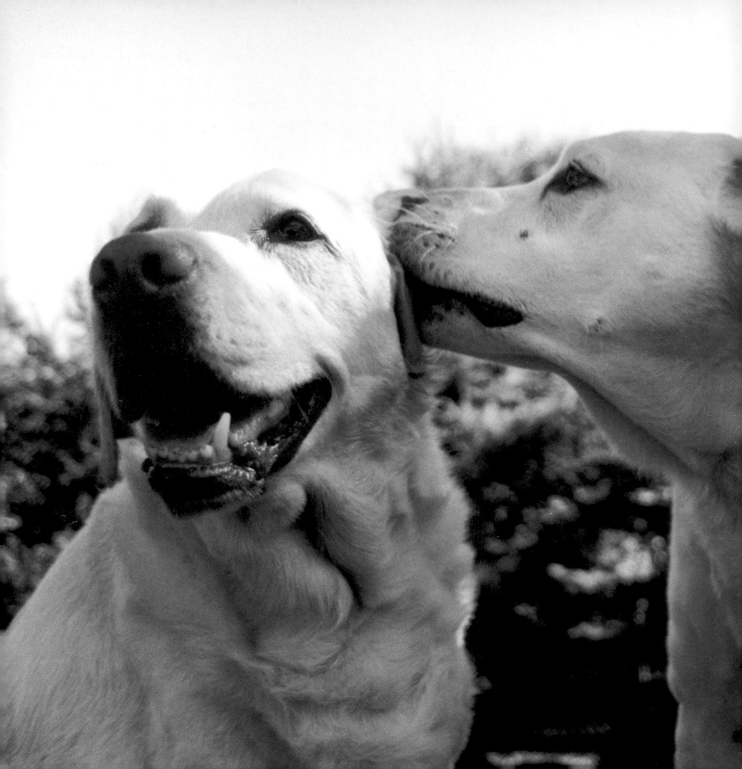

Nuzzling up to both of them, I tried to keep them awake because they looked so comfortable and loving with each other.

Lucy and Boomer (opposite) are best friends and have lived together for over ten years. They love each other, and I wanted to convey the emotional connection they share. Lucy cleans Boomer's ears daily. But for some reason, the one picture I got of them kissing was the other way around—Boomer kissing Lucy. His owner said this almost never happened. But on this day, it did. I was lying on the ground with my camera facing up at them. I liked the way the sky enveloped their heads. They were not aware of my presence in this moment. They were thinking only about each other.

I used my Nikon F100, with 100 T-MAX film and a wide-angle lens. The purpose of using the wide-angle lens was to provide a broader view of the sky around their heads.

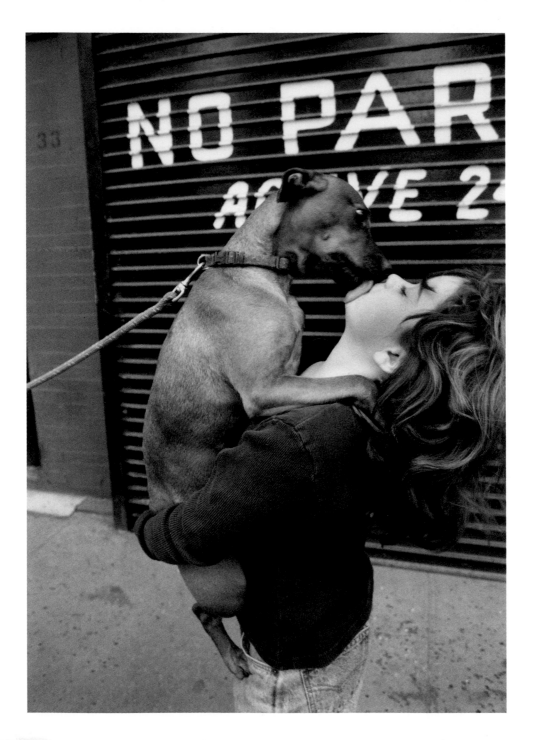

Between Dog and Owner

The image (opposite), titled "Kiss", was taken on the Lower East Side in New York City. Upon first glance, it appears to be a simple street photograph, but I tend to think of it as a classic moment between owner and dog. Walking through the streets of New York City with my camera years ago, I noticed a young girl walking her dog. Suddenly, the dog jumped into her arms, and I immediately raised my camera to take the picture.

This image illustrates the instinctual love that dogs have for their owners, and vice versa. He isn't just kissing her—he's hugging her, too.

If you are experimenting with documentary and street photography, you have to be ready at any moment to take the picture. This kind of candid or spontaneous portraiture relies much more on instinct and timing, and less on style and setup.

Tip: Capturing a moment between two dogs or a dog and his owner requires good timing, a good eye, and strong instincts. Set your camera on automatic, concentrate on your subject, take lots of frames, and be patient as you wait for the moment to happen in front of the lens.

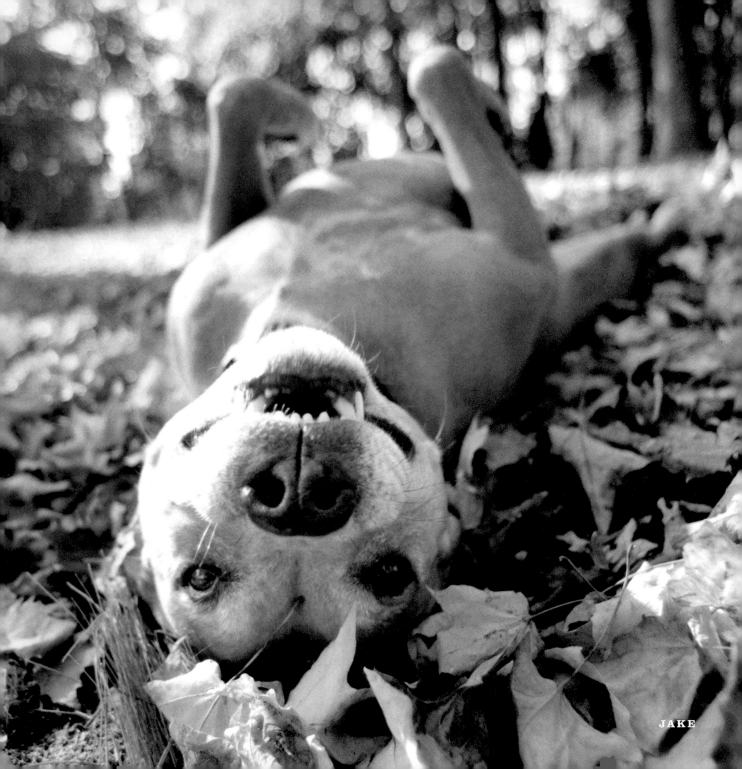

JAKE

Down on Their Level

BUDDY

Getting down on the same level as the dog is an approach that I use throughout my work. It has become an essential part of my photographic style. There is a great benefit to placing yourself at the same level as your subject. It helps you view the world from the dog's perspective. This technique also helps you gain trust, an essential element to creating a relationship with your subject. This will result in images that evoke a dog's emotion and personality.

The image of Jake (opposite) illustrates his happiness and good nature. Jake, a pit bull terrier, was a total mush of a dog. He was photographed on a crisp autumn day, as the leaves were falling all around him. Using my Nikon F100 and a wide-angle lens, I lay down on the ground with him. I rubbed his belly to gain his trust and got him comfortable with being on his back. Then I took this shot. My focus is on his face and smile, but I like that you can see his whole body as well as the backyard. It gives you a sense that he has a loving home, which is not the case with a lot of pit bulls. Jake is one of the lucky ones.

Buddy's image (left) is another that illustrates the benefit of getting down on the same level as the dog. Buddy was a puppy who had a lot of energy. He spent most of our shoot running around the park as I tried to catch up to him. Eventually, he tired out and flopped down on the grass. Being ever patient, I lay down right next to him and opened up my wide-angle lens to $f2.4$. Photographing Buddy at this angle helped highlight the sincere look in his eyes.

Tip: Take your pictures at the dog's eye level so you can see the world as he does. It helps you connect with your subject, resulting in a more emotional and relevant image.

HIGGINS AND MURDOCH

[3] Photographing Outdoors

Photographing outdoors seems so natural since most dogs love being outside. There are many benefits to photographing outdoors. You can take advantage of natural light and the environment surrounding your subject. Dogs, especially big ones, tend to feel carefree and excited at the prospect of being outdoors. There are many interesting places in which you can photograph dogs, and each background creates a different looking image.

You may want to do some research when determining where to set up your shoot. One thing to ascertain is whether the dog knows commands such as "sit" and "stay." This information seems so basic, but it will determine whether you allow the dog off-leash or not. If you have a dog that listens to basic commands, you will have more freedom during your shoot. Obviously, photographing the dog without a leash will make for a stronger portrait, but the dog's safety should be your number-one priority. I have photographed many, many dogs that don't listen well and had to be on a leash while outdoors. Throughout the following sections, I will give examples of how to handle this kind of situation.

The portrait of Higgins and Murdoch (opposite) was taken on a boat launch on Block Island in Rhode Island, where I was on vacation. One day, I took my camera down to the launch and found Higgins and Murdoch waiting for their owners. They were quite amenable to having their portrait taken. The boat in the background makes this photograph much more interesting than it would have been if taken against a more basic background. The boat provides information about time and place and captures the outdoor aspect to these dogs' lives.

Tip: Spend time determining the setting and location for your shoot and choose one that suits the type of dog you're photographing.

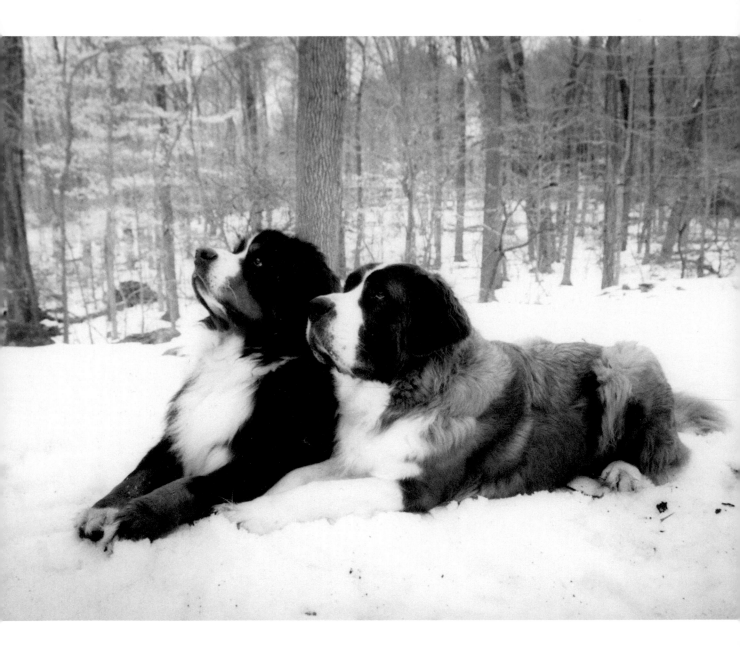

BARON AND POUILLY

The Woods

The woods offers a spectacular background for photographing dogs. In my experience, big dogs photograph well in the woods because their size can handle the detail of the trees and branches. Smaller dogs, on the other hand, can get lost in the woods (literally and figuratively!), so I tend not to photograph them there.

Java, Puck, and Jessie lived in a home with the woods surrounding it. Taking their portrait in the woods was essentially like taking their portrait in their backyard. For this image (page 36), I used my Nikon F100 and a 35–70mm lens, with 400 Tri-X film because the wooded area was shaded. Java, Puck, and Jessie were well trained and knew how to sit and stay. Once my shot was set up, I called their names and they looked right at the camera. While this is a more traditional portrait, it captured these three companions in a place they loved.

Baron and Pouilly (opposite), a Bernese mountain dog and a Saint Bernard, respectively, also lived in a wooded area. Since they were such big dogs, I wanted the background to be as important as they were. That is why I used a wide-angle lens to show the magnitude and beauty of the setting. It is not a traditional portrait, as the dogs are not looking at the camera. Rather, they are looking up at their owner with admiration and love. The serenity of the snowy woods provided a special background for their portrait.

> **Tip:** Photograph large dogs in a wooded setting, as their size can handle the detailed background better than small dogs.

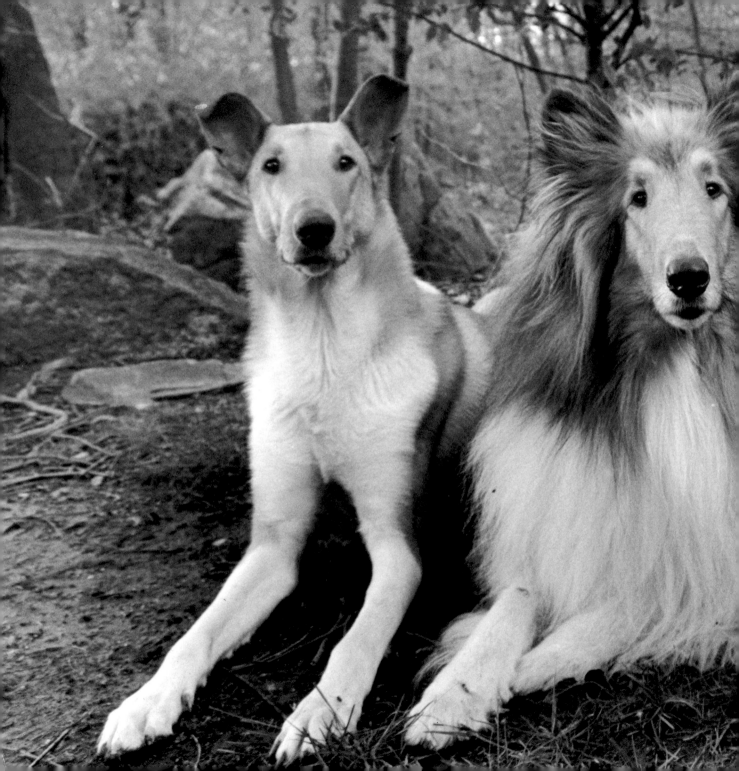

JAVA, PUCK, AND JESSIE

SAMMY

The Beach

RILEY

One of my favorite locations in which to photograph dogs is the beach. There are certain breeds of dogs (e.g., Labrador and golden retrievers) that love swimming and frolicking in the ocean. They also love chasing sticks and playing ball in the sand. Most dogs enjoy the freedom of the beach because they are not confined and can run all over. You will want to make sure that you understand the dog's nature prior to letting her off-leash at the beach.

Once you're prepared, you can take your time photographing the dog swimming and playing. In my experience, it is rare to have a dog stand in one place for too long at the beach, so be prepared to take some action shots.

This image of Sammy (opposite) is an example of a portrait against the backdrop of the ocean. She waited patiently for the tennis ball as I took her picture. There is a sense of urgency to this image even though Sammy is standing still. The lines and positioning of her body against the contrast of the sky and ocean make it a striking beach portrait. I used my Nikon F100, 400 Tri-X film, and a wide-angle lens.

This portrait of Riley (left) was taken on the Jersey Shore. He had never been to the beach before and was apprehensive about the ocean but was fascinated by the sounds of the seagulls. I like that his portrait captured his regal look and the texture of his fur.

The great thing about the beach is that there are a lot of areas that make interesting backgrounds—the ocean, the dunes, the boardwalk. The portrait of Fly (page 41) was taken in the dunes. Fly was not obedient and therefore had to be leashed. I draped the leash behind him and sat in the dunes with him. Fly spent the

BEACH DOG

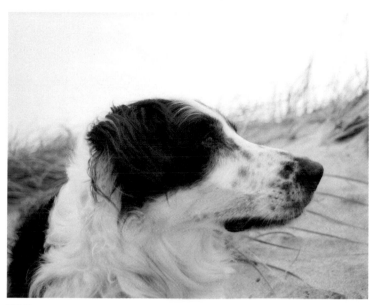

FLY

Tip: The beach provides a beautiful setting for portraits. Consider experimenting with the various beach elements (e.g., ocean, dunes, boardwalk) to create different backgrounds for your pictures.

majority of our shoot barking at me! When I played my harmonica, he barked even louder. So I decided to give up that tactic and let him experience the beach in his own way. I didn't expect to capture him looking to his side, but I caught the one moment when he did.

You don't always need to see the water or the dunes to take a strong beach picture. "Beach Dog" (opposite) captured a young lab puppy begging for a tennis ball while playing at the ocean. The texture of his wet fur gives the sensation that he is at the beach—without the ocean in view.

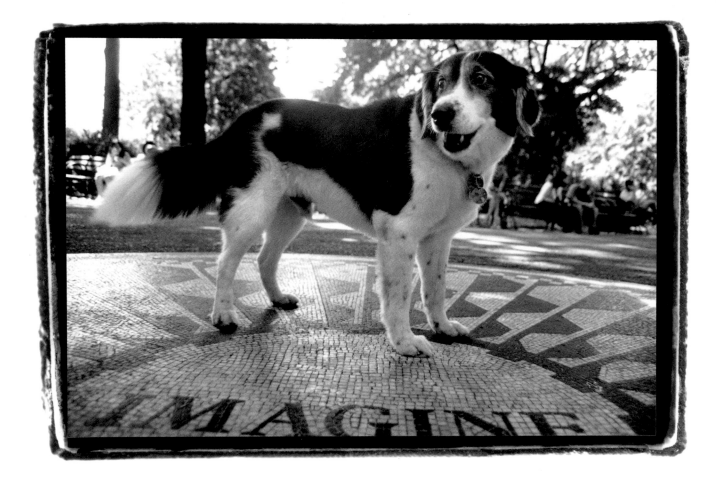

The Park

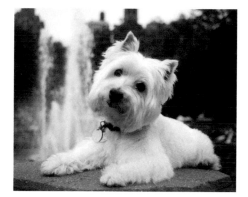

As I mentioned in the introduction of this book, I initially started taking dog portraits in various dog parks around New York City. A park setting provides another great backdrop for classic dog pictures.

This portrait of Riley (left) was taken at Washington Square Park in New York. We placed her up on the cement stand in front of the water fountain. I played my harmonica, and she tilted her head in perfect harmony with my camera. Using my Nikon F100 and 400 Tri-X film, I was able to capture some detail in the fountain behind her. If I had used a lower speed film, the fountain would have ended up looking like a big blur. My intention is for the eye to fixate on Riley and to show that we were at a famous park in the city. Her inquisitiveness against the background of the fountain made an engaging portrait.

The background of the next portrait was also a famous spot in New York. The image of Max (opposite) was taken at Strawberry Fields in Central Park. Max had inhabited the city for many years, and he and his owner were moving. We thought it would be nice to take his portrait in an area that was special to both of them.

I placed myself on the ground underneath Max and used a wide-angle lens so I could see his whole body as well as the detail of the circle. You get the feeling from his expression that he is imagining and thinking about his life, even though he is a dog. I like to think that the picture tells the story that Max is reminiscing about his life in the city, and he is ready for his new life in the suburbs!

Tip: If you are looking to show a wider scope of your background so your pictures tell a story, consider using a wide-angle lens at the park. Choose a setting in your town or city that has some history.

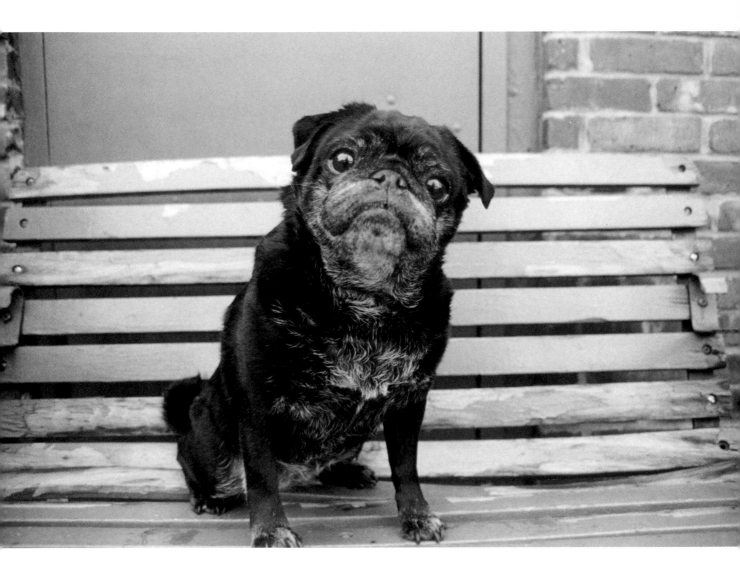

WALLY

ZOEY

Dogs love to play and romp in the park. This portrait of Zoey (left), taken with my Nikon D200 and a 400-speed setting, captures her love of sticks and determination in carrying quite a large one! Zoey was far more interested in retrieving sticks than in posing for the camera.

The Bench

One of my best tricks for photographing small dogs is placing them up on a bench. If you are photographing a dog who must be on a leash, putting the dog up on a bench allows you to drape the leash behind him so it won't be seen in your shot. This is also a way to be at eye-level with your subject. Lastly, placing a small dog on a bench gives you more control over the dog, as he is less likely to jump off and run away.

Tip: Placing small dogs up on a bench provides you greater control over your subject and allows you to be eye-level with the dog. The bench also provides a textured background for your pictures.

Wally, a ten-year-old Pug, was graying around his mouth. I thought the bench was the perfect setting for this elder statesman. Wally's portrait (opposite) expressed his humorous personality and his cute figure. This image was taken with my Nikon F100 and a wide-angle lens. I used my harmonica to get him to look at the camera.

I have tried to place larger dogs on benches and found it didn't work as well. Large dogs are too big for benches and end up looking uncomfortable. Small dogs act more natural and relaxed.

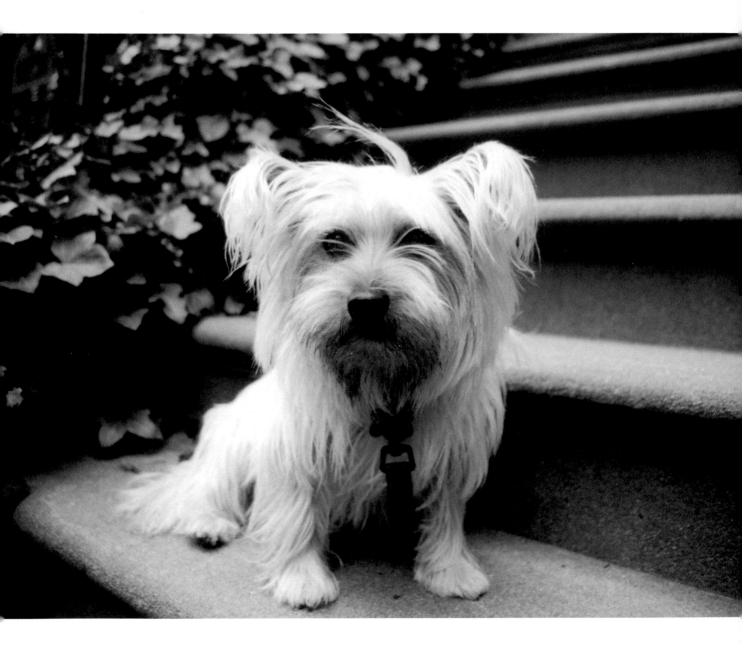

ELLA

The Front Steps

FRANKLIN

Placing a dog on a row of steps is a great way to get it to stand still. Even a poorly behaved dog is capable of standing on steps and not running. If you place yourself in front of the dog so that you are between her and the street, you will be able to grab her if she tries to run. This is a technique that I use often, especially with dogs that don't listen well.

Similar to a bench, the front steps provide a clean, textured background for your images. It also gives a time and place to your portrait. Make sure that your background is clean and doesn't have too much detail. You want to make sure that your subject stands out.

This image of Ella (opposite) was taken on the steps of her brownstone. She was quite comfortable on the steps. Even though there were a lot of sounds from the street, Ella was focused on my camera and on me. My goal was to capture her easygoing personality and relaxed nature. The wisp of her hair was an added bonus!

Franklin (left) also enjoyed hanging out on his front steps. I used my harmonica and familiar words to get his attention. The composition of Franklin's long, lean body against the lines of the steps makes a striking visual. His portrait showcases his handsome frame and regal personality.

> **Tip: Front steps provide a clean, textured background for your portrait. Also, dogs tend to stay still on steps, allowing you to concentrate on simply getting their attention.**

47

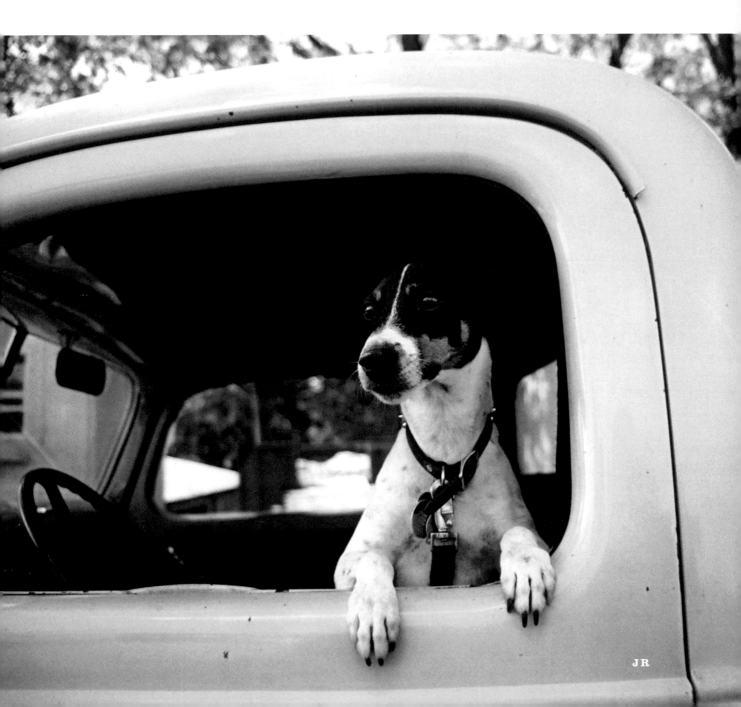

J R

The Car

There is nothing funnier to me than seeing a dog in the driver's seat of a car. Putting a dog in a car serves a couple of purposes. First, if the dog doesn't know basic commands, he will sit still inside a car. Most dogs also love to go for rides in the car, so this is a place where they are happy and excited.

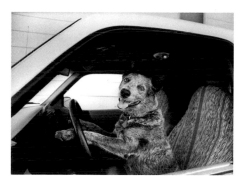

WRANGLER

I got lucky with Wrangler. He was a stunt dog who knew how to pretend to drive a car. He placed his paws on the steering wheel, and I used my harmonica and some familiar words like "go for a ride" to get his attention. I used the technique of shooting close up and opening my aperture to ƒ2.4 to show that he was inside of a car. Wrangler was quite a character—he turned his head and smiled for the camera, as if he was winking at the viewer. This portrait (left) captures Wrangler's humorous and engaging personality. Details, such as the color and style of a truck or car, can also add flavor to a pet portrait.

JR was photographed inside his yellow pickup truck (opposite). As soon as I saw the truck, I knew we had to take his portrait in it. I used my Nikon F100 with a wide-angle lens and called JR's name to get him to jump up on the window. He was a little apprehensive about being inside the truck. Keep in mind that getting the dog to look right into the camera is not necessary to making a good pet portrait. This image of JR is more about his environment than his personality.

For obvious reasons, it may not be a good idea to take pictures of a dog in a car on a hot day. The dog will be uncomfortable and may end up panting in the car.

Tip: A car provides a great setting for a photo shoot. Experiment with various angles and lenses so you can show that the dog is inside of the car.

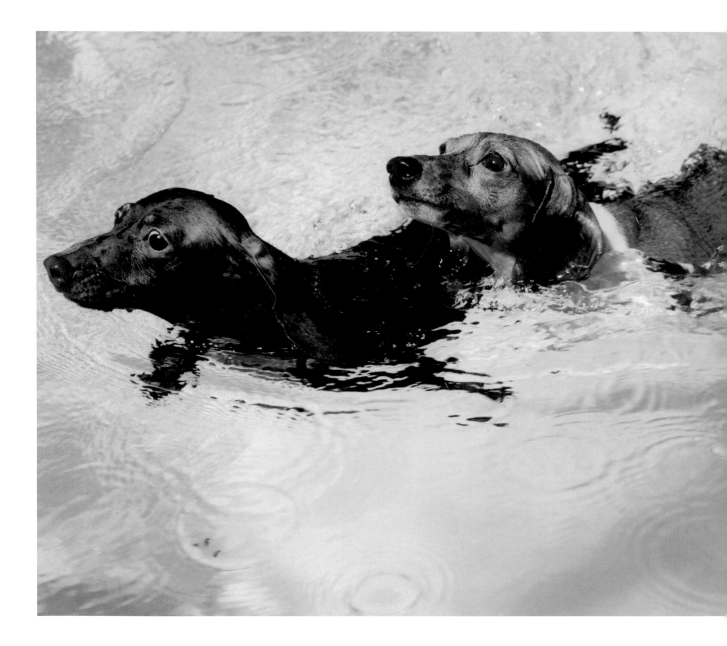

ZOEY AND ZEUS

The Water

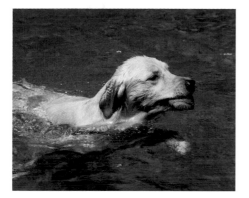

MIA

I always look forward to photographing dogs in a swimming pool. Zoey and Zeus, two dachshunds, loved to swim. This photograph (opposite) was taken on a hot summer day, and they wanted to cool off. I placed myself at one end of the pool and used a wide-angle lens to show them swimming from one end to the other. Once they reached the end of the pool, we took them out and brought them back to the other side to start again. It takes time to take great pool pictures so you need to be patient.

I was asked to photograph a dog pool-party a few years ago. Since most of the dogs attending this party were golden retrievers, they couldn't resist swimming in the pool. I took this image of Mia (left) with my Nikon F100 and Fuji Color Pro 400H speed film. I kept my camera on its automatic setting because there were many dogs jumping in the water and chasing balls. It was a chaotic environment but one that was also a lot of fun.

> **Tip:** When taking photographs of dogs swimming, keep your camera on its automatic setting because your subjects will be moving quickly through the water. If you spend too much time fiddling with your camera, you may miss a great action shot.

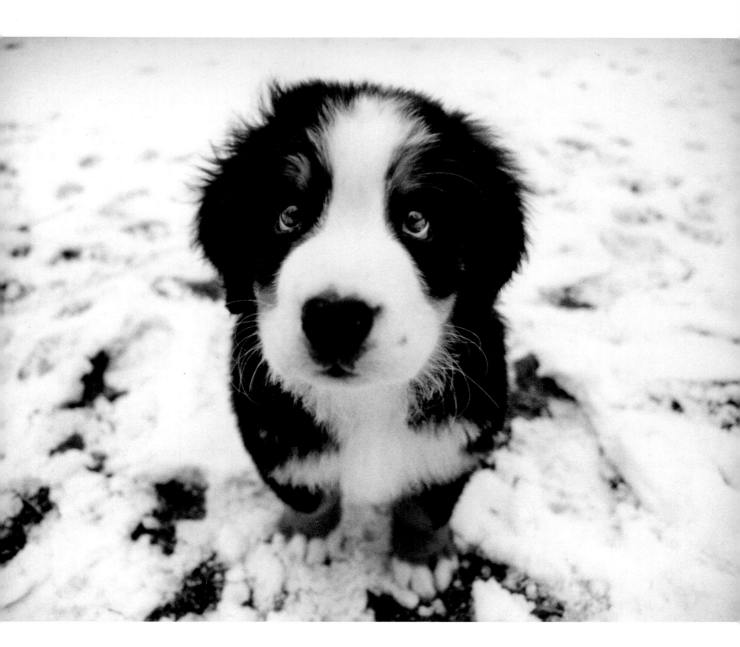

BEN

The Snow

Photographing in the snow is a blast for both the photographer and the dog. Most dogs love the snow and are fascinated by its texture and coldness. Something basic to remember when you're photographing in the snow is to protect your camera from getting wet. If it is snowing while you are shooting, ask someone to hold an umbrella over your head so you can concentrate on taking good pictures.

This photo of Charlie (left) was taken at the exact moment a snowball was thrown in his face. We kept throwing snowballs at him hoping to catch him eating it. One element that worked well in this image was the contrast of Charlie's black fur against the white snow. Consider photographing with black-and-white film or with the black-and-white setting on your digital camera. The whiteness of the snow tends to pop more in black and white.

This portrait of Ben (opposite) illustrates the fascination that dogs, especially puppies, have with snow. I stood over Ben and shot down at him with a wide-angle lens. This technique creates a particular effect: It makes the dog's head look bigger than the rest of its body. (Before you use this method, be sure this distorted look is what you want.) This technique worked well with Ben, as this was his first snowfall, and the image captures his curiosity and innocence.

CHARLIE

Tip: Photograph in black and white to enhance the contrast of the snow against the dog's fur.

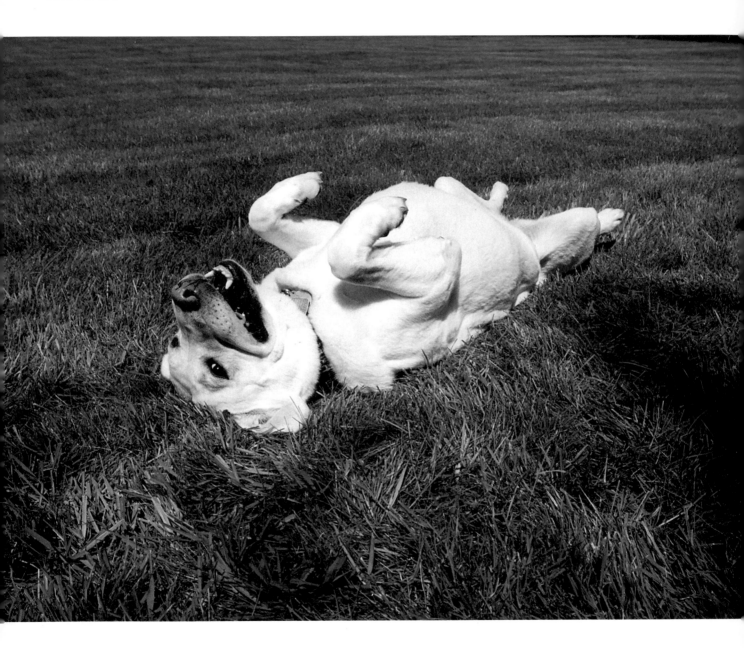

ZOË

The Grass

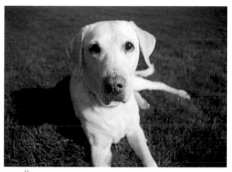

ZOË

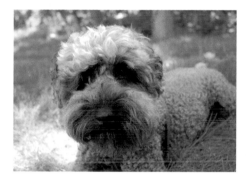

TOMMY

Photographing a dog in a grassy setting allows you to focus on the details in the dog's face and expression because the background is clean and simple. For this portrait of twelve-year-old Zoë (top left), I lay down on my stomach so I would be at eye-level with her. She was relaxed in front of the camera. My goal was to highlight her sweet expression and laid-back personality. I used the same approach when photographing Tommy sitting in his backyard (bottom left).

Dogs get very playful in the grass. This second image of Zoë (opposite) was taken when she was quite a bit younger. She rolled on her back unaware of my camera. I was on the ground in front of her with my wide-angle lens focused on her face and tummy. The end result was a picture of her whole body frolicking in the grass.

Tip: Dogs like to roll around and get playful in the grass, so be prepared to get down and dirty with your subjects.

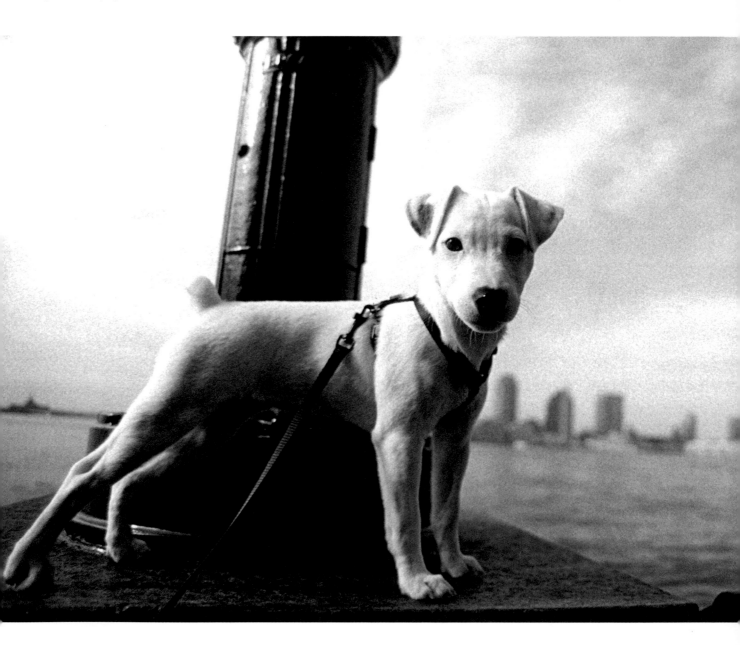

RAGAN BY THE HUDSON

The City

One of the things I love about photographing in a city is the texture and details of the streets, buildings, restaurants, and shops. It doesn't matter if it is New York, Paris, or Dublin; city life provides an amazing backdrop to any kind of pet portrait.

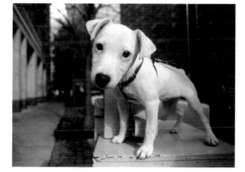

RAGAN ON NEWSPAPER STAND

Photographing dogs in the city never gets boring. I have two different approaches to city or street photography. When I have an assignment in a city setting, I approach the day as a photojournalist. My goal is to document the experience of the dog in the city. I look for a variety of backgrounds that fit the type of dog I am photographing. Illustrating this approach are the three images of Ragan, a three-month-old Jack Russell terrier. These images tell a story about Ragan's experience in New York City.

Since Ragan was a puppy and was being photographed in the city, she couldn't be taken off her leash. Therefore, we looked for places to put her from which she couldn't jump off or run away. Using my Nikon F100 and 400 Tri-X film, I used my wide-angle lens to capture her small stature against the larger-than-life architecture of the city.

In the "Hudson" image (opposite), Ragan was positioned on a cement light stand in Battery Park City. The background was the Hudson River and New Jersey. I sat underneath Ragan and opened my wide-angle lens to ƒ2.4. I then blew on my harmonica to get her attention. The wide-angle lens showed a wider view of river and sky with Ragan still the focal point of the image.

The next image of Ragan (above left), "Ragan on Newspaper Stand," illustrates her inquisitive nature. Her owner held a treat above my right ear to keep her still. Once I took the picture,

Tip: Use a variety of settings to document the dog's experience in the city. Approach the day as a photojournalist.

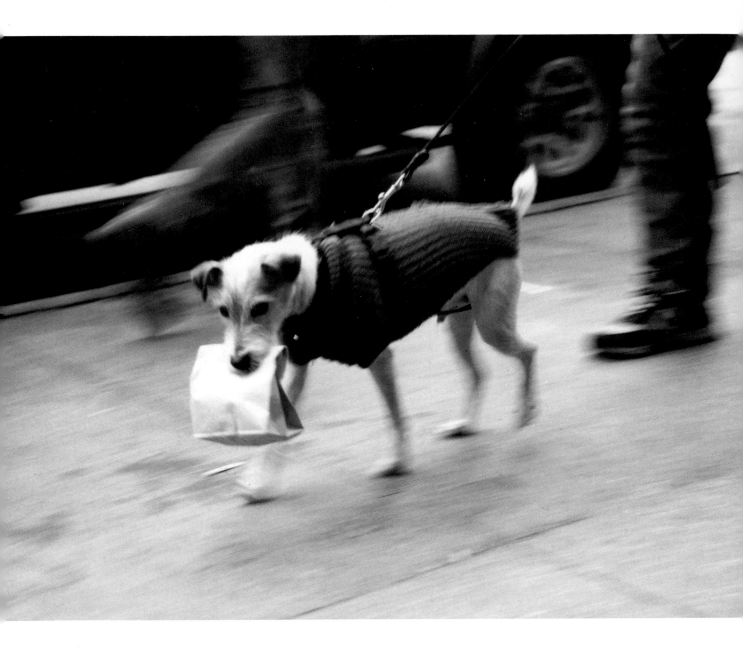

ELROY

RAGAN IN THE CITY

she received her reward. Again, using my wide-angle lens helped give the impression that Ragan was larger than she really is.

The last image of Ragan (left) was taken against the city's buildings. I had Ragan's owner hold her up to the sky and I lay down on the ground so that I could see the buildings surrounding her. Using a wide-angle lens showed a wider scope of the background, ultimately making the portrait more interesting.

The Street

The other approach I use when taking portraits in a city is that of an observer. If I do not know the dog I am photographing, I have a different technique in taking city portraits. City dogs are street-smart and savvy, and they tend to take on the personality of the city itself.

Back in 1996 when I started Bark & Smile Pet Portraits®, I was living in the West Village in New York. I didn't have to travel far to find interesting subjects to photograph. I took this image of Elroy (opposite) right outside my apartment. He was walking down the street and had a paper bag in his mouth. Elroy was walking with chutzpah and determination, and that energy is reflected in the movement of the image. I bumped into him a few weeks later in my neighborhood, and his owner told me that he had been carrying a bagel in his paper bag!

STRETCH

I didn't know Elroy, but as a dog lover and photographer, I was aware of his presence as he was coming down the street. My instincts as a photojournalist kicked in, and I caught Elroy's love of the city on film.

I approach photographing dogs on the street similarly to how I photograph people on the street. I use my camera as a way to introduce myself. I start taking pictures as I am talking to the person or animal. I also try to observe the dog's world from his perspective. "Stretch" (opposite) was taken at the Blessing of the Animals in New York. I sat on the street and looked through my camera at all of the dogs waiting in line to be blessed.

With my Nikon N90 and a wide-angle lens focused on this array of shoes and dogs, I noticed this terrier mix stretching back as he was waiting in line. The people's shoes and activity around him created a strong composition to this image. The picture tells a story about this particular day and his experience in the city.

Photographing dogs on the street in any city can be fun and exciting. The next time you're traveling, make sure to have your camera handy so you can capture the city's soul through the eyes of its most soulful inhabitants. 🏠

Tip: Approach street photography as an observer. Take time to compose your shot observing the activity and scenery surrounding your subject.

61

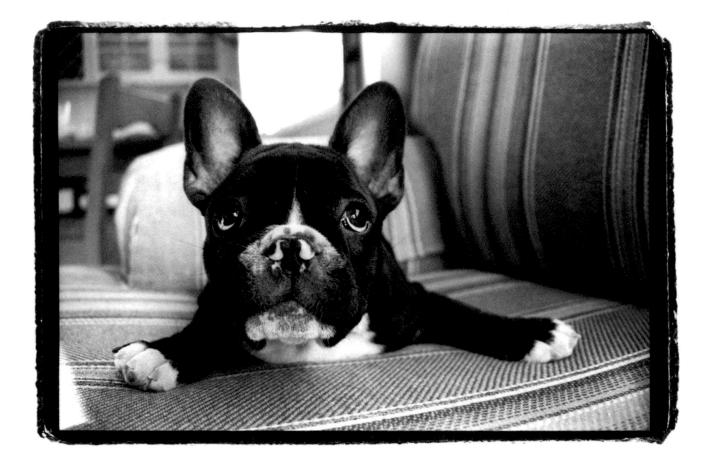

HUGO

4 Photographing Indoors

When I set up indoor shoots, the first thing I do is determine how much natural light is available. Since I prefer the look of natural light, I set up my shoots at times when the most sunlight is available.

Natural Light

This portrait of Hugo (opposite) is an example of the effect of photographing indoors with natural light. Using my Nikon F100 and 400 Tri-X film, I placed a couch in the sunroom where the most sunlight was coming through the windows. If you are shooting with your digital camera, set your ISO to 400 or higher. Keep in mind that the higher the speed of the film, the grainier the image will be. Additionally, you may need to open your aperture as wide as possible ($f2.4$) to attain enough light.

I positioned Hugo so the light coming through the window was in front of him, not behind him. I made sure that there were no shadows on his face and body. Once my lighting was determined, I focused my attention on Hugo. The end result was a humorous portrait of a French bulldog puppy with ears almost as big as his head.

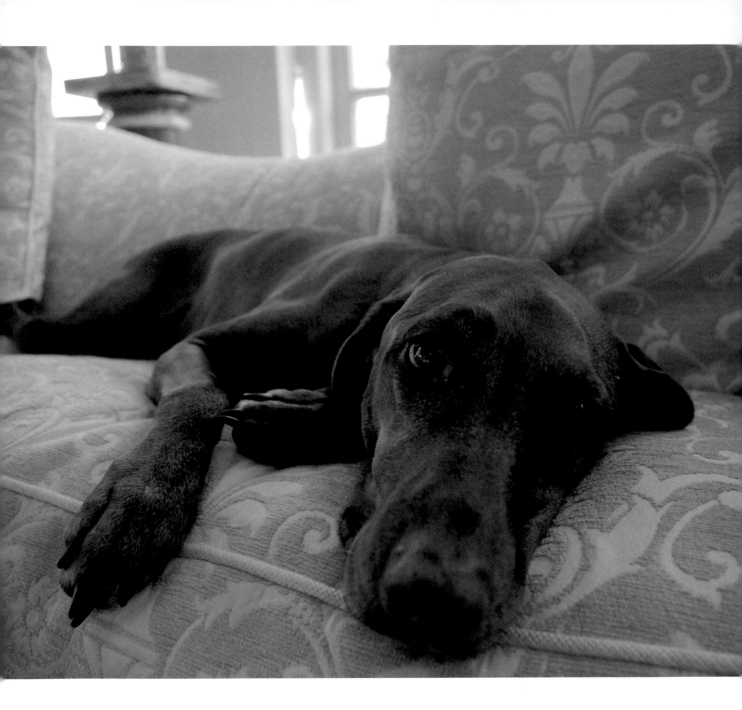

GISELLE

> **Tip:** To ensure you have enough natural light for an indoor shoot, use high-speed film (400 or higher) and an open aperture (*f*2.4). Set up your shoot in the room that has the most natural light available.

This color portrait of Giselle (opposite) uses a similar lighting technique. The image was taken with my Nikon D200 and my camera at 400 ISO speed setting. The main light source was coming through the window behind the couch; however, there was enough light throughout the large room to illuminate the detail in Giselle's face. The beautiful light enhanced the color of Giselle's golden fur against the warm, yellow couch.

Shooting indoors with available light will help you avoid the red-eye that happens so often with the use of a flash. Natural light also provides a softer look.

You may be wondering what to do if you don't have enough available light and you don't want to use a flash. One trick is to find some lamps and surround your subject with enough lighting to avoid using the flash. If you have a digital camera, you can view your images as you are taking them; this way you can see if your setup has enough light. If your images remain blurry, you do not have enough light and may need to resort to an overhead flash.

Flash

Even if you prefer the look of indoor portraits with natural light, an overhead flash is a necessary piece of equipment for any photographer. If you do not have a separate overhead flash, you can use the flash on top of your camera, but you will not have as much flexibility.

Unfortunately, some dogs are scared of the flash. This was the case for Boopie, a Maltese I photographed in her home. She was petrified either of my flash or of me, so she hid in the bathroom. With my Nikon N90 and an overhead flash, I followed

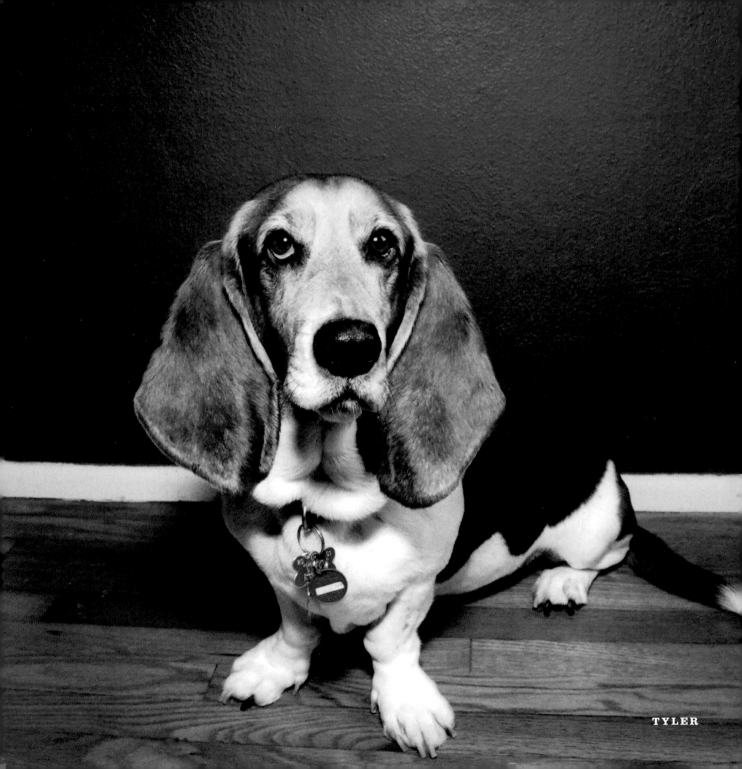

TYLER

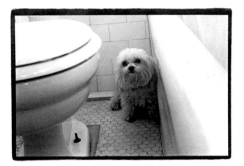

BOOPIE

her in there. Boopie hiding behind the toilet made a much more interesting portrait (left) than the one I had planned on taking.

One technique that makes flash shoots go smoother is setting your overhead flash to its TTL (Through the Lens) mode. If you have a good flash unit, the TTL mode will adjust the level of light automatically. In addition, always use higher speed film when photographing indoors. If you're shooting with a digital camera, set your ISO setting to 400 or above.

Another technique that is helpful in avoiding red-eye is to bounce the flash off the ceiling so that it hits your subject indirectly. This way, the flash is not going directly into the dog's eyes. You can use this bounce-flash technique if you have a flash unit that is separate from your camera. When you use a bounce flash, make sure there is enough available light coming in from other sources. You may want to experiment with setting up an additional light on the right or left side of your subject.

This image of Tyler (opposite) was taken with my Nikon N90, Fuji Color Pro 400H film, and a bounce flash. I had some available light coming through the window, so I bounced my flash toward the ceiling. Tyler stood against a blue wall and was actually fascinated by my harmonica, so getting his attention wasn't hard. I also experimented with the flash going directly into Tyler's face, but it was too strong for the portrait I wanted to capture. ⌂

Tip: Consider using a bounce-flash technique to soften the light hitting your subject's face.

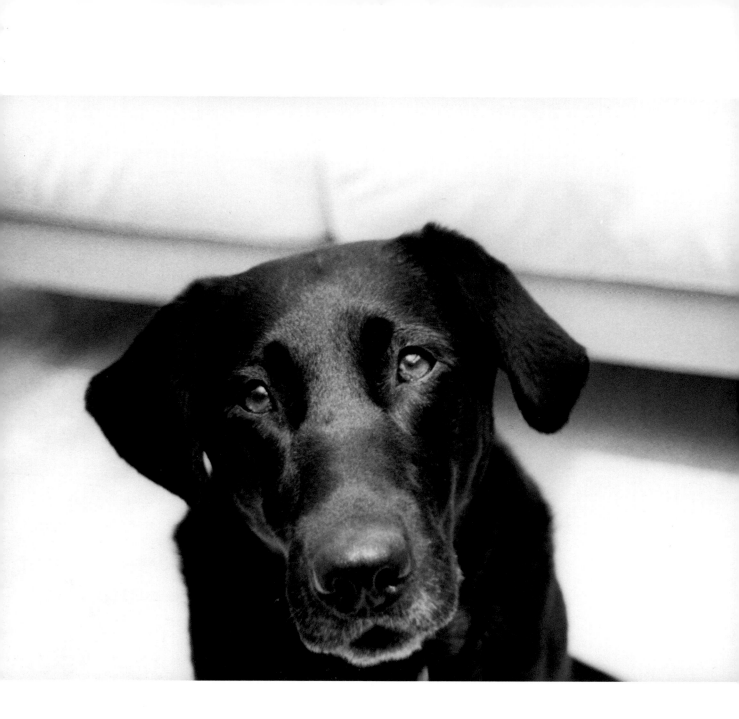

5 The Black Dog

One of the biggest challenges in dog portraiture is photographing a black dog. The concern is that you will lose all of the detail in the dog's face. Since black dogs are so common, it is good to know some basic techniques for photographing them indoors and outdoors.

Indoors

There are several options you have while photographing a black dog indoors. The first is to use an overhead flash. This will ensure that you see the detail in the dog's face. A fill-flash technique helps increase the detail in a black dog's face. Set your camera on the TTL mode and aim the flash directly at the dog.

While the fill-flash technique works well in adding detail to a black dog's face, you risk giving the dog red-eye. For that reason, I have always made it a practice to bounce the flash so that the light doesn't go directly into the dog's eyes. You will need to make sure that you have enough indoor light to use this technique. You can add a studio light or available lamp on the side of

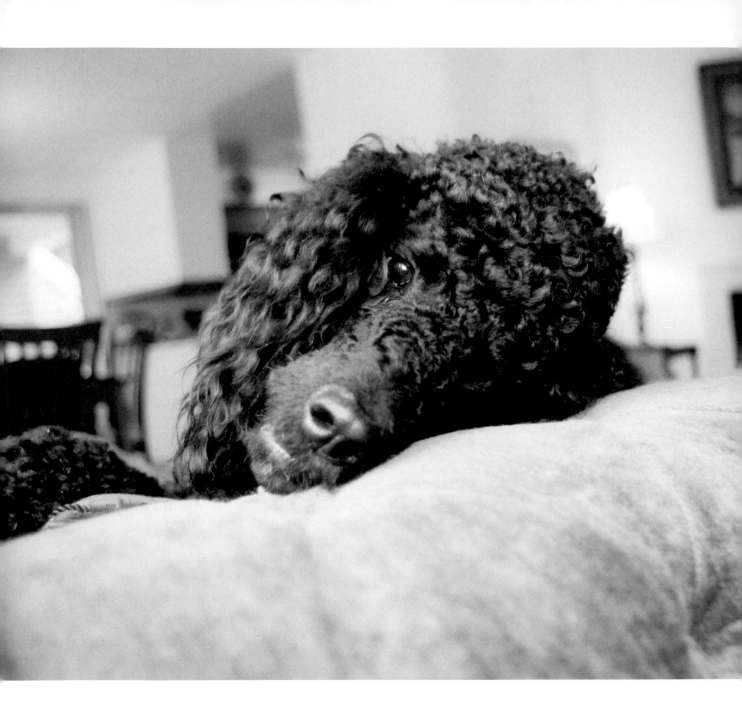

your subject to increase the level of light. This way you can avoid red eye while maintaining detail in the dog's fur and eyes.

Another technique is to photograph the subject in a room with a lot of available light coming through the windows. I open up all of the shades and flood the room with as much natural light as possible. I open up my aperture as wide as it will go (f2.4), and I shoot at a higher shutter setting (1/250).

I utilized all of these techniques in taking the portrait of Mango (page 68). I photographed her at an angle where the sunlight was meeting her face so that you could see the detail in her black fur. I didn't set the shutter speed higher than 1/250 because I didn't want my portrait of Mango to appear grainy. I like the inquisitiveness in her face and the light in her eyes.

The portrait of Max (opposite) was taken in front of a window. Max was positioned on the sofa looking toward my main light source. He settled comfortably into the sofa, and I began taking his picture. I used my Nikon F100 with Fuji Color Pro 400H film and a wide-angle lens.

A digital camera is advantageous when photographing a black dog because you have the ability to view your pictures. You also have the opportunity to adjust your images in Photoshop should your images turn out darker than you expected. However, for the amateur photographer who is not adept at Photoshop, it helps to experiment with your subject in a variety of different lighting scenarios.

Tip: Use a higher shutter speed and higher speed film when photographing a black dog indoors. Consider using an additional light source or a fill-flash to enhance the details in the dog's face.

71

Outdoors

The same techniques apply when photographing a black dog outside. If you are shooting in a low-light situation (e.g., in the shade or on an overcast day), using a fill—flash to highlight the details in the dog's face can be helpful. While I do not love the look of the fill-flash in outdoor photography, it is necessary to use it on certain occasions.

Another approach is to position the dog in an area with direct sunlight. Make sure that the sun is behind you and that you don't have a strong shadow from yourself or the dog in your frame. Sometimes the sun can create a shiny coat on a black dog—this may or may not be a look you like.

This portrait of Bentley (opposite), a seven-month-old Newfoundland, was taken on a bright, sunny day. Since he had black fur, the sunlight really helped illuminate the details in his face. Zoey (page 74) was also photographed on a beautiful sunny day, but her backyard had areas of sun and shade. I was careful where I positioned her in the yard. I wanted the sunlight to light her facial features; however, I did not want her coat to look too shiny. The final image was a beautifully lit portrait.

Tip: Using a fill-flash or positioning a black dog in the sun will help bring out the details in the face.

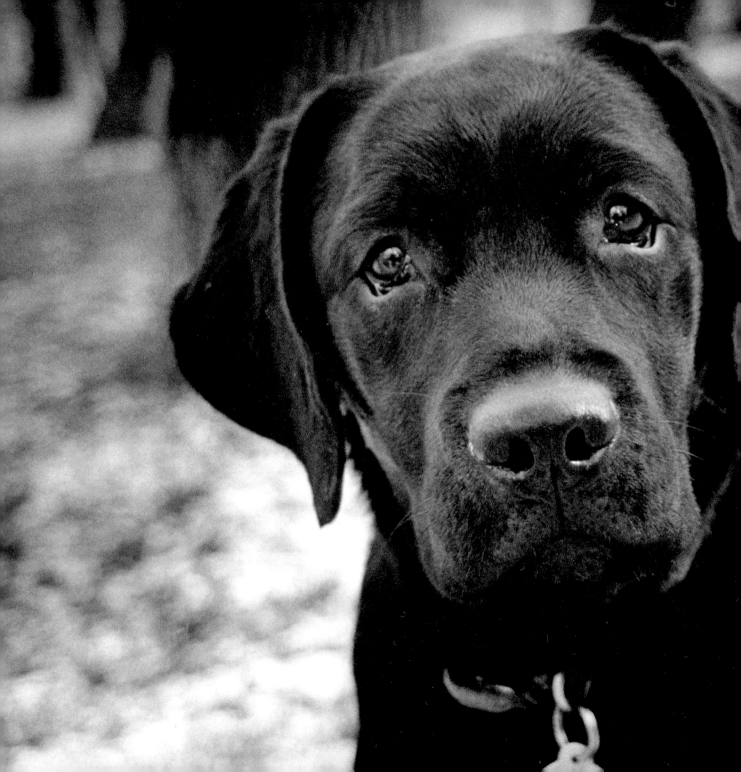

ZOEY

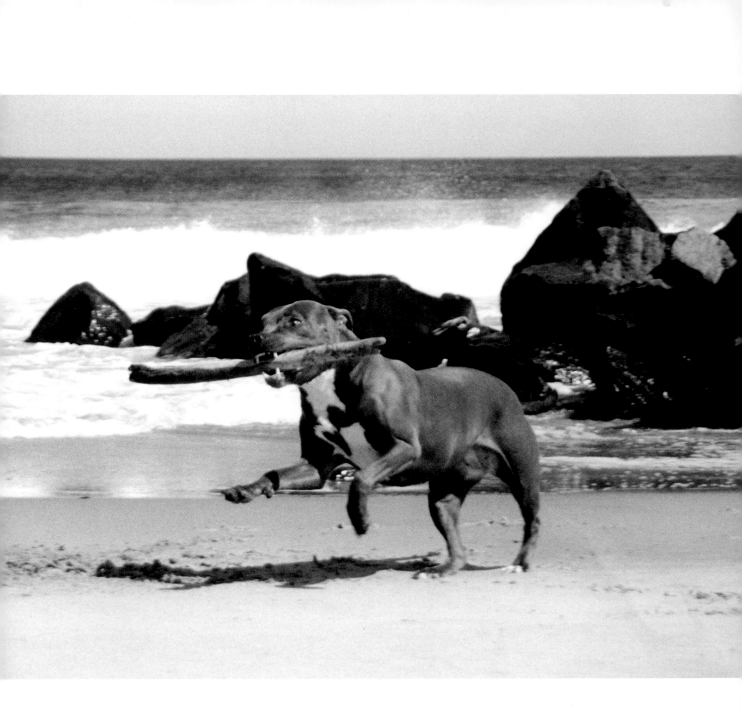

SAMMY

6 The Dog in Motion

There is an art to taking good action pictures of dogs.
Since dogs love to run and play, there are some techniques that can make your action shots more compelling.

Use faster film (400, 800) and a faster shutter speed (1/250, 1/500) to capture movement and create the look of motion. If you're shooting digitally, set your digital camera to an ISO setting of 400 or higher. Usually 400-speed film/digital setting will stop action, as illustrated in this image of Sammy at the beach (opposite). Sammy was gallivanting about with a stick in her mouth. Shooting with my Nikon F100 and 400 Tri-X film, I set my shutter speed at 1/500 to capture her energy and excitement. Keep in mind that the faster the film, the grainier the image turns out, so there will be a tradeoff when taking action photographs.

CHEYENNE

CHARLIE

Feel the Movement

The photograph of Charlie (above) is a good example of an image that allows you to feel the movement of your subject. Using my Nikon F100, 400 Tri-X film and a fast shutter speed (1/500), I attempted to capture Charlie's speed and agility. He was chasing his friend Lucy around the yard. He's quite a fast dog, and you really get a sense of his length and speed in this image.

Even though the image is not in focus, the blurriness of it creates a striking visual and gives the viewer a sense of how fast he was moving. Not all action shots have to actually stop the action.

Panning the Camera

This photograph of Cheyenne (opposite) utilized the technique of panning the camera in a circular motion as she was running

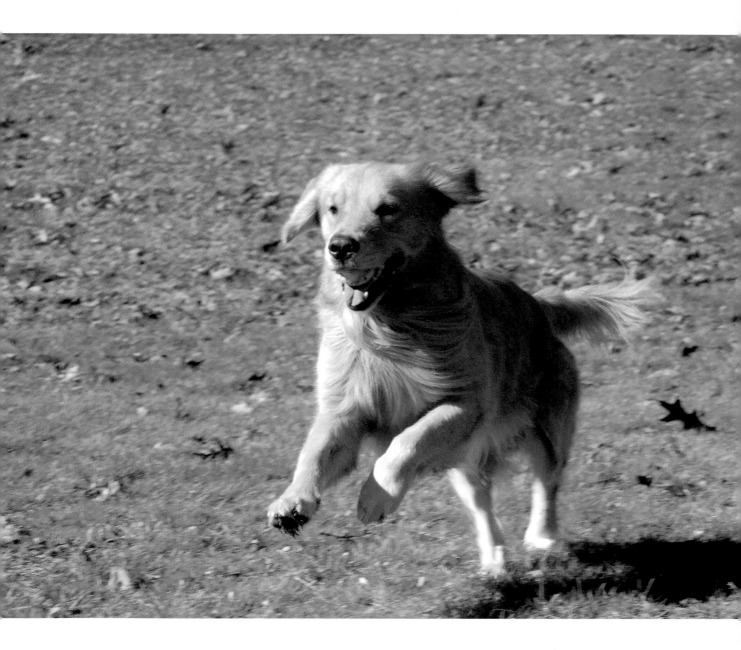

OLIVER

LILY AND RILEY

around her yard. The composition of this image—the dog is not centered and seems to be jumping out of the picture—adds to its effectiveness.

Cheyenne was running around in figure-eight circles, and I panned my camera in a circular motion. My camera was set at a high shutter speed, and I continued to move with Cheyenne as she rounded every corner. This technique works well when trying to capture dogs running, chasing, or playing ball. I was dizzy, but the end result was worth it!

Stopping Action

If your goal is to catch the dog mid-movement, you have a better chance of doing so with high-speed film and a faster shutter speed. If you are shooting with a digital camera, you need to make sure that your camera shutter speed is high (1/250, 1/500) and that your ISO is set on at least 400 speed. I have noticed that when my digital camera is set at 400, my images are quite sharp if I am shooting with enough available light.

I took this photograph of Oliver (opposite) on a bright, sunny day, and the colors in the sky were as vibrant as his fur. With my Nikon D200 set at 400 speed and a higher shutter speed, I caught Oliver in midair catching the ball.

"Lily and Riley" (above left) is another example of stopping action using higher speed film and a fast shutter speed. I took this portrait during a beach shoot. Lily was chasing Riley in the sand. It was their first time at the beach, and they had a blast chasing each other and cavorting at the ocean. ⬆

Tip : Use faster film (400 or higher) and a faster shutter speed (1/500) when taking action photographs. Keep in mind that these techniques may result in a grainier photograph.

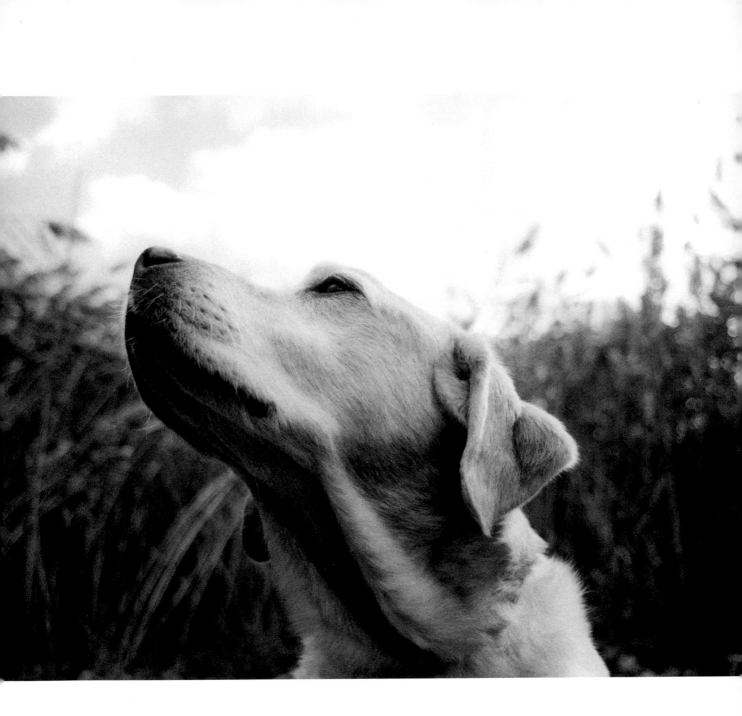

ZIPPER

7 Composition

How you frame and compose your shots is what sets your images apart from others. And the way you look through the camera is going to be different from the way any other photographer does.

There are a lot of photographers who started taking pictures because they felt they had a good eye, myself included. While it is easy to teach camera techniques, it is not as easy to teach someone how to have a good eye; this is something that is innate. However, you can teach someone how to develop a better eye and how to frame a picture. Learning how to use compositional elements in your photography can turn an ordinary photograph into an extraordinary one. This image of Zipper (opposite), a laid-back yellow Labrador, highlights her serene and soulful nature against the beautiful reeds in her backyard. What makes the photograph stand out is the compositional line from her nose down to her neck.

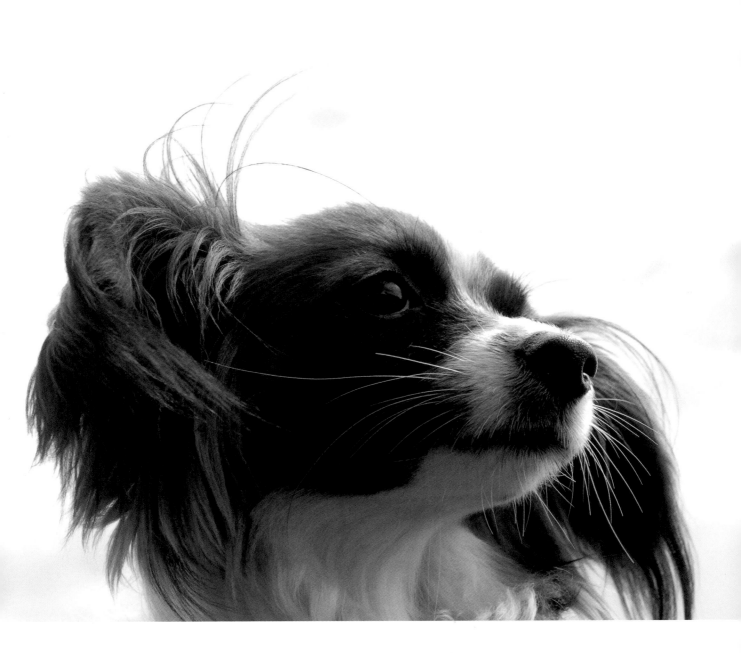

PAPILLION

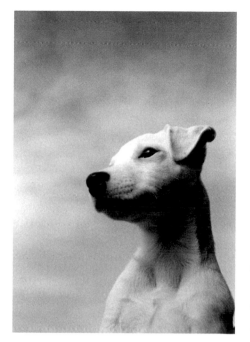

RAGAN

Unusual Angles

The portraits of Ragan and Papillion are both good examples of composing an image utilizing unusual angles.

Ragan (left) looks like she's floating in the sky. And she almost is. I had her owner lift her up high because the clouds and the overcast sky made a great background. Turning the camera vertically lengthened the lines of her neck. If Ragan were centered in the frame as opposed to being off-center, the image would be less interesting. Both the unusual angle and the overcast sky make "Ragan" a striking portrait. The dog's profile and sweet expression also contribute to the feeling this image evokes.

The same elements of angle and sky apply to "Papillion," which was taken on a bright, colorful day (opposite). The angle of the dog's head looking out over the sky and the softness of the light make this portrait unique and compelling.

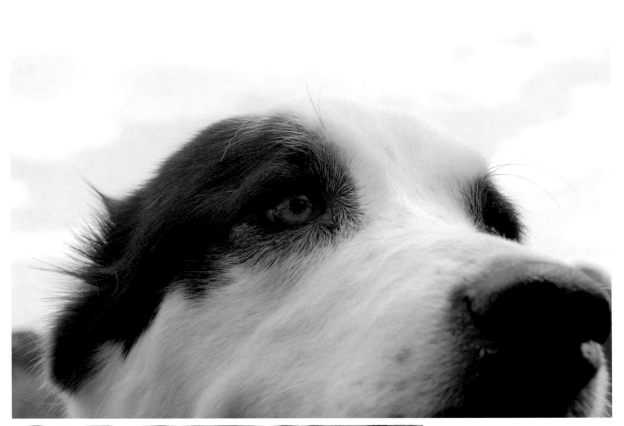

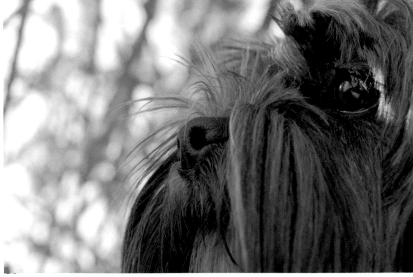

Top: **MIDDLE ASIAN OVCHARKA**
Bottom: **RAMONA**

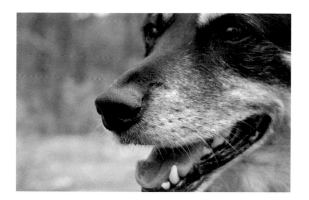

LUCY

Framing

How you frame your subject in the lens of the camera is another element of composition. Placing the dog in the corner of frame, as shown in the picture of Ramona (opposite, bottom) makes the portrait interesting and nontraditional. It is still a close-up portrait, but because it is off-center and uniquely framed, its composition stands out.

The image of Lucy (above) is another example of how framing can enhance a portrait. Lucy was a sweet and happy dog, and her photo session was taken at her favorite walking trails. After taking several portraits of her straight-on, I moved extremely close up to her and placed her face in the right corner of my lens. I liked this angle because I felt it illustrated her bliss and excitement that day.

This Middle Asian Ovcharka (opposite, top), a large-breed dog that I had never seen before, was at an animal welfare event in New Jersey. This image is another example of how framing can enhance a portrait. Framing a portion of the dog's face makes you imagine what he is looking at. The clouds surrounding the top of his head also contribute to the whimsical nature of the portrait.

Tip: Placing the dog in the right or left corner of the frame of your lens can strengthen the overall composition of your portrait.

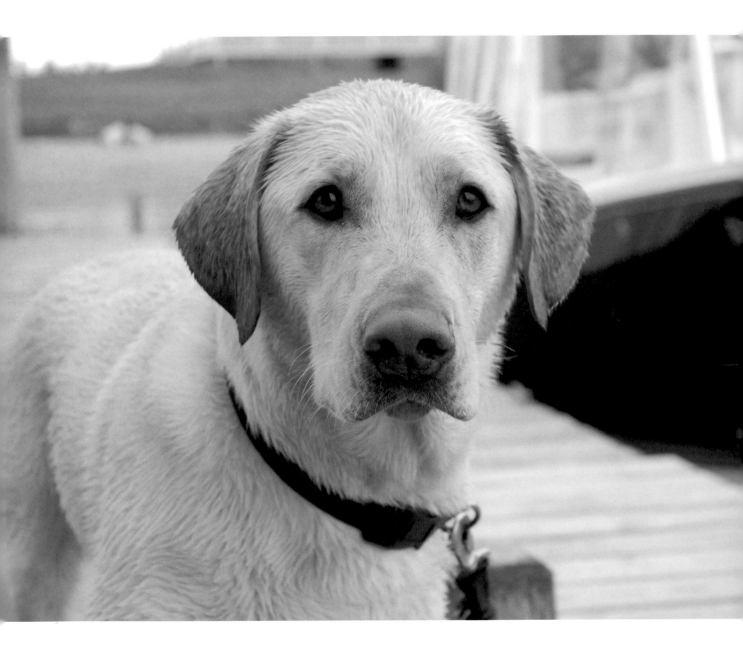

HIGGINS

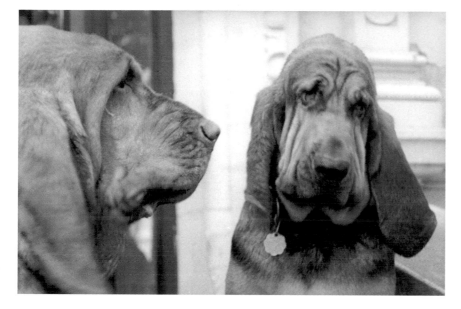

BLOODHOUNDS

Texture

I love photographing dogs with wrinkly skin, such as pugs, bulldogs, basset hounds, and bloodhounds. The texture of their skin adds another visual element that you can experiment with.

"Bloodhounds" (above) is an example of a well-composed photograph for several reasons. I am always asked if this is one bloodhound looking in a mirror. It is not. The two faces looking in different directions make people think it is a mirror reflection rather than an image of two dogs. Their wrinkles contribute to the overall effect of the portrait. I took this shot with my Nikon N90 and 400 Tri-X film.

This portrait of Higgins (opposite) is another example of how the texture of a dog's fur draws your attention to the focal point of the photograph. Higgins's wet fur is so sharp that you can see each individual strand against his skin. I took this picture with my Nikon D200 and a 400 ISO setting.

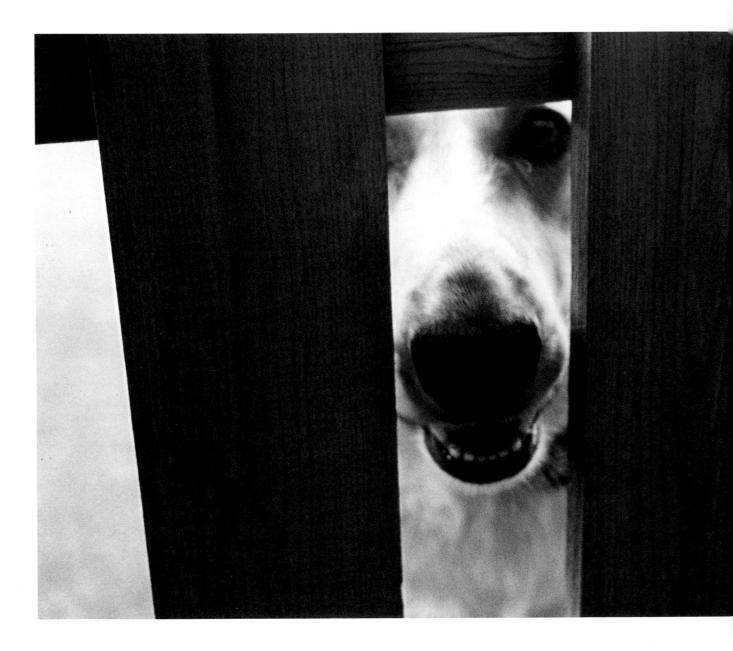

OTTO

Lines and Form

Lines and form are additional compositional elements that enhance the effect of a photograph. This image of Otto (opposite) was taken while the dog was peeking through his fence. The lines of the fence framing Otto's curious face make this an interesting portrait. The texture and detail of a simple backyard fence strengthens the overall composition of this image.

Form is an aspect of composition that is not as tangible as texture or lines, but it is an important concept to grasp. Form is more about figures and shapes. In this portrait of Hunter (page 92), it is the shape of his body and his positioning in the grass that draws your attention. The serene look in his eyes and the relaxed nature of his body add to the mood of the photo as well.

As you may have realized from looking at the images in this book so far, one of my favorite ways to photograph dogs is by lying my stomach. This is part of my personal style and an approach that I use often to compose and frame my pictures. Once I am comfortable and my camera is positioned, I can concentrate on getting the dog to react to me. This was the technique that I used when photographing Hunter. I tried to make Hunter comfortable by speaking to him sweetly and softly. Developing a rapport with your subject while you are taking his picture is essential to great pet portraits.

Tip : Look for details such as texture, lines, and shapes as you are creating your portraits.

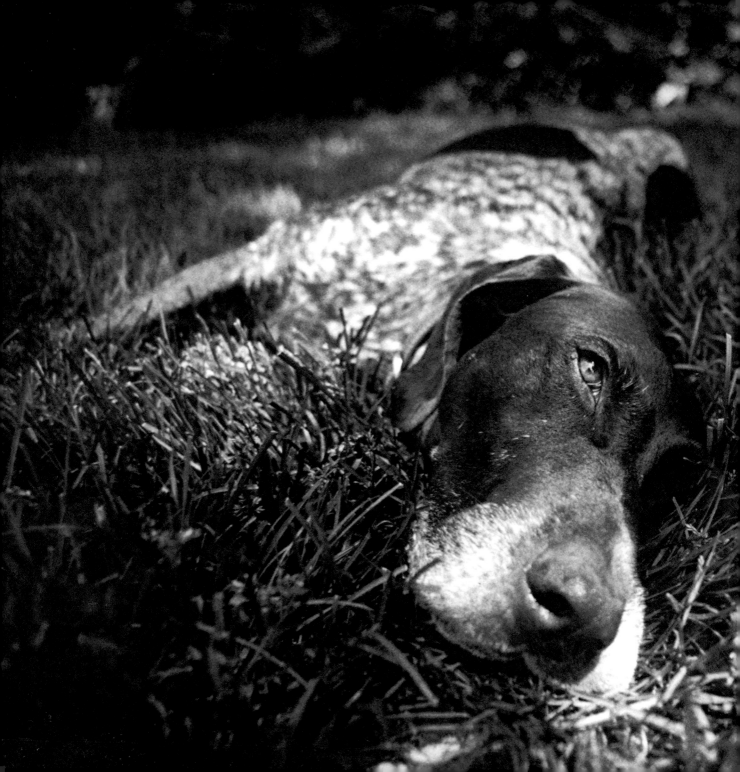

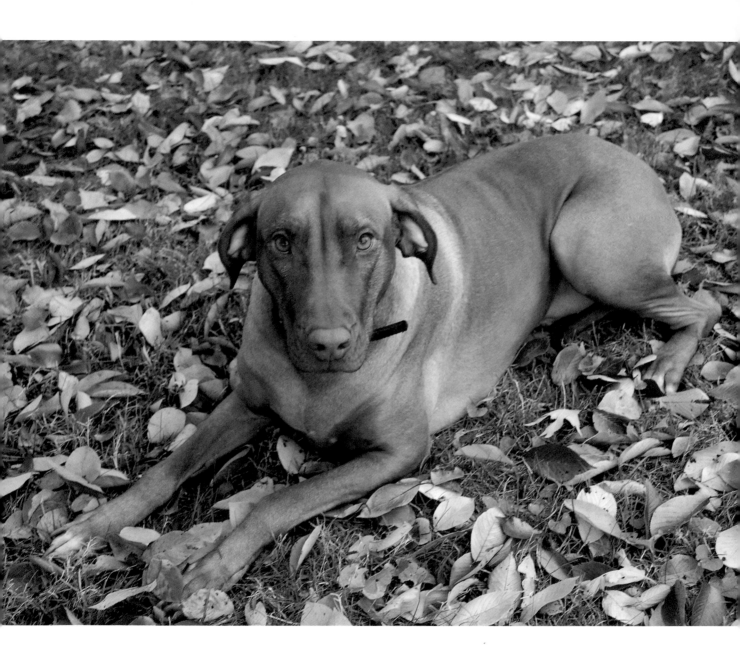

TUCK

18 Making Use of Weather and Seasons

Elements of drama or color provided by weather and/or seasonal conditions can greatly enhance your portraits. Most people think they will get the best images by shooting on a bright, sunny, "picture perfect" day, but this is not necessarily the case.

In fact, inclement weather, such as rain and wind, or an overcast sky can provide a much more interesting atmosphere for your portraits than a sunny day. The four seasons also offer a range of settings for interesting pet portraits. as illustrated in this portrait of Tuck (opposite). Tuck's burnt-orange fur looked magnificent against the colorful autumn leaves, making this a quintessential fall portrait.

JOHNNIE WALKER

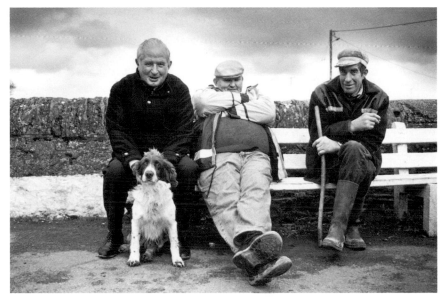

SPANIEL WITH THREE MEN

Weather/Wind

The weather on the day of your shoot can have an effect on the mood of the dog. For example, if it is raining outside, the dog may look sad or subdued. Sometimes the weather creates a distinct mood or feeling to your portrait.

Consider the two portraits "Spaniel in Thought" (page 98) and "Spaniel with Three Men" (above), which I took while vacationing in Ireland. On this particular day, a huge rainstorm had passed through and the sky was dark and overcast—my favorite kind of weather for photography. I happened upon the men and their spaniel in the town of Wexford. The dog was sitting on a bench overlooking the ocean, and the clouds enveloped his head.

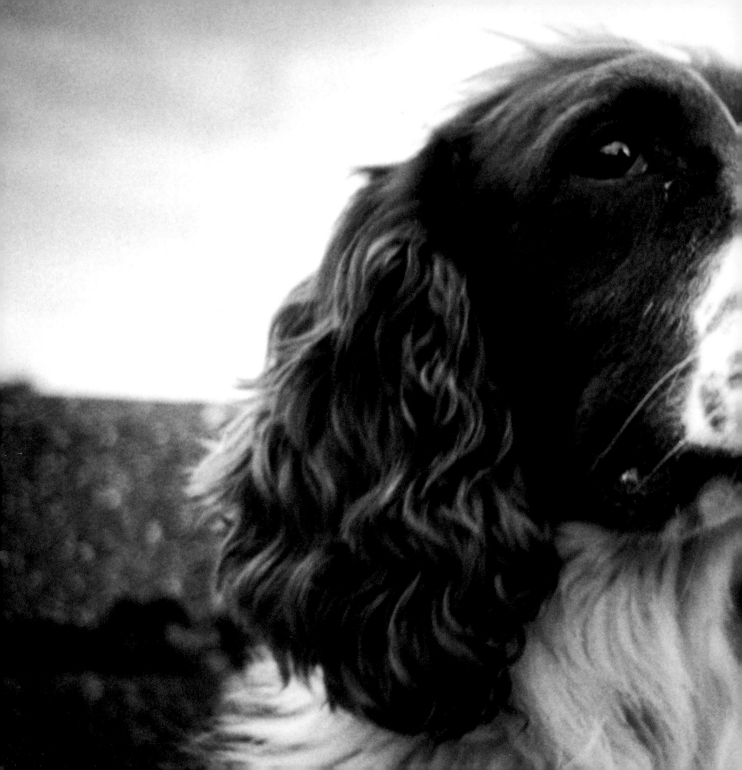

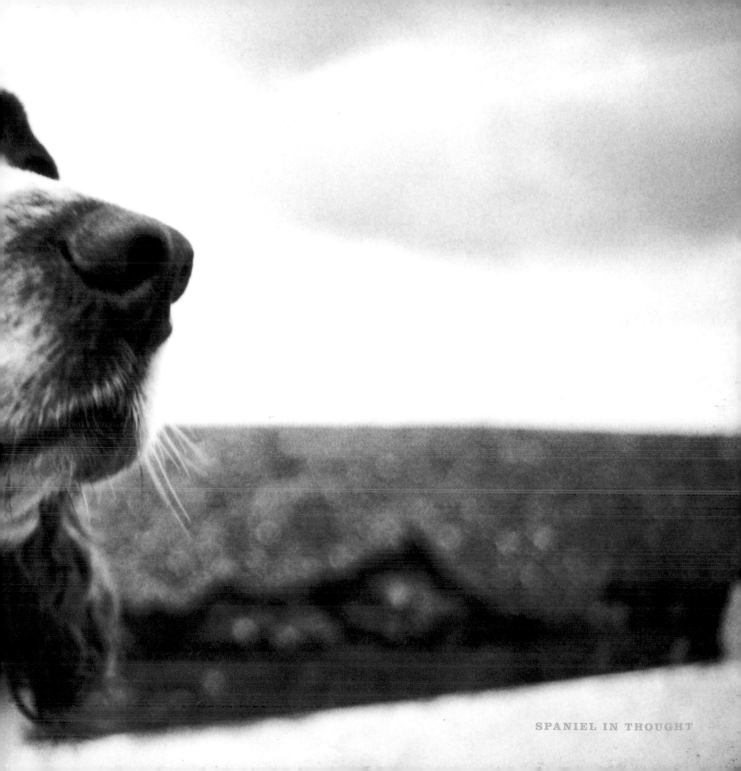

SPANIEL IN THOUGHT

AUDREY AND WATSON

I took this image of the dog alone by sitting underneath him so that my camera was facing up to the sky. I used my Nikon N90, 400 Tri X film and a wide-angle lens because I wanted to show the clouds surrounding his head. The spaniel was relaxed and at ease in my presence. I talked to him sweetly and did not use any noises or words that would startle him, and so he continued looking out at the ocean. The end result was a dramatic portrait that was as much about the weather as it was about the dog.

Sometimes it is a challenge to photograph dogs outdoors because you have to be prepared for how the dog will react if the weather is poor. A good example of this was my portrait session with Johnnie Walker (page 96). An older dog, Johnnie was not very happy about having his picture taken on a windy day in the fall. In fact, it was so windy that I was concerned my images would look blurry. I chose to shoot with a higher speed film (400 Tri-X) and a faster shutter speed (1/250) to ensure the extreme weather would not cause blurriness. The net result was an image of Johnnie that captured both the windy weather and his serious mood.

The portrait of Audrey and Watson (opposite) was taken on the steps of the boardwalk at the beach. Because it was the dogs' first trip to the beach, I kept them closer to the boardwalk to have more control of them. Even though Audrey and Watson are standing still, you get a strong sense of movement due to the wind blowing against their fur. I laughed throughout the shoot because their hair is usually perfectly coiffed—but not on this day. They smiled in every photo because they were experiencing the beach for the first time. I took this portrait with my Nikon D200 and a wide-angle lens so that I could show the beach setting in the background.

Tip: Different types of weather and overcast skies can add atmosphere to your pictures, but just be sure to adjust your ISO speed film/digital setting and shutter speed/aperture to meet your needs for light.

ANITA

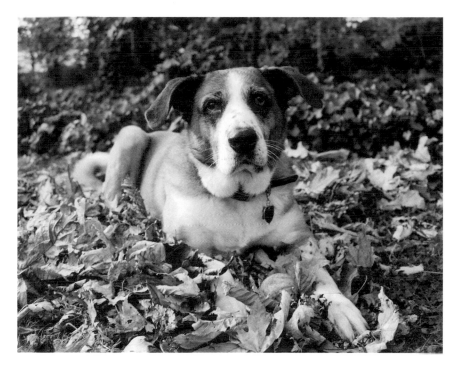

CASEY

Seasons

Photographing in the spring and fall works well because the weather isn't too hot for dogs, and you avoid having dogs' panting in your portraits. Spring brings both rain and beautiful flowers for great backgrounds.

This bright and colorful portrait of Anita (opposite) was originally taken for the annual ASPCA calendar. As she was the cover girl for the month of April, it made perfect sense to take her portrait surrounded by tulips. Using my Nikon F100 and Fuji

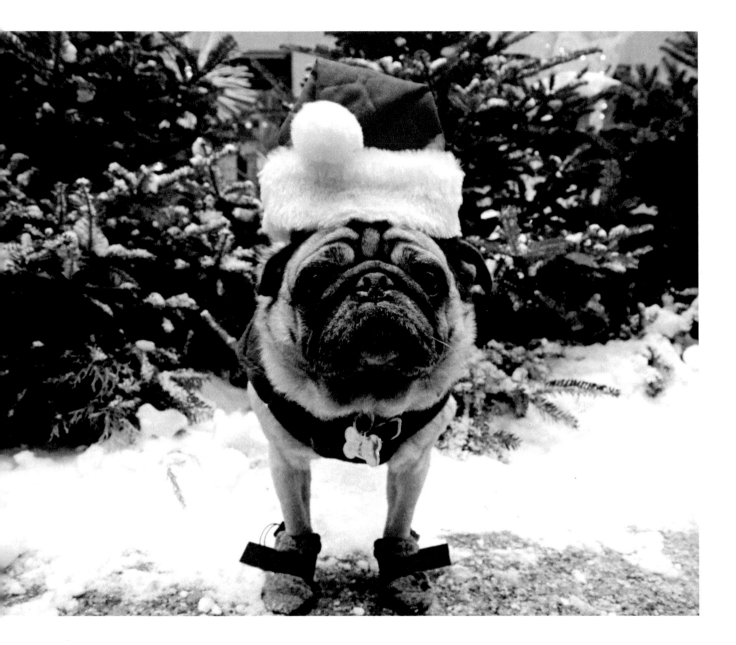

HARLEY

Tip: Colorful background elements related to the seasons, such as autumn leaves and colorful springtime flowers, will enhance your portraits and add visual interest.

Color Pro 160C film, I placed Anita up on a ledge so she couldn't jump down and run away from me. She was obviously enjoying the spring weather that day, as she had a permanent smile on her face. I used my handy trick of playing the harmonica and making high-pitched noses to get her attention.

Casey (page 103) was also photographed for the annual ASPCA calendar. An older dog, Casey was rather subdued sitting in the colorful leaves on a crisp autumn day. Her sad yet hopeful expression was telling, as this image was selected for the cover of the calendar.

Lastly, this image of Harley (opposite), a pug, was taken in Rockefeller Center in New York. Harley was also featured in the ASPCA calendar for the month of December. Dressed in his winter sweater, boots, and Santa hat, Harley was easy to photograph. He knew basic commands and perked right up when I called his name.

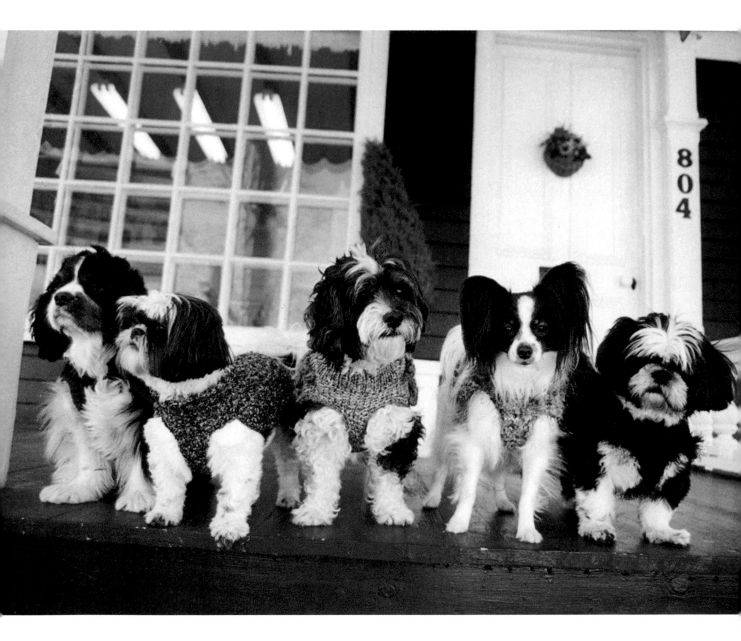

CHARLEY, ALLIE, BILLY, EMILY, AND DAPHNE

9 Dogs, Dogs, Dogs

Taking photographs of multiple dogs can be extremely challenging for obvious reasons. Unless you have well-trained dogs who respond to basic commands, it is a challenge to photograph several dogs at once. If you have dogs that listen to basic "sit" and "stay" commands, then consider yourself lucky!

The key to taking good portraits of multiple dogs is using familiar words (for example, "Go for a ride!"), treats to get them to stay, and noises and sounds to get their attention. If you stick with these three tips, you have a decent chance of getting a funny and engaging picture. The photograph of Charley, Allie, Billy, Emily, and Daphne (opposite) is a good example of these three elements working together cohesively. Posing for a shot for a dog-sweater company, these dogs were dressed up and photographed on their front porch. They were small enough to stay on the porch and responded well to my harmonica and high-pitched sounds.

Let's first turn our attention to the easiest type of dogs to photograph: well-trained ones.

The Group Portrait

Photographing the Amazing Mongrels, a dog comedy troupe that traveled the country, was one of the highlights of my career. I traveled to Knoxville, Tennessee, to photograph the troupe for a book titled *Working Dogs: Tales from Animal Planet's K-9 to 5 World.* They were performing at the Comedy Barn, and I had the opportunity to photograph their performance. I laughed

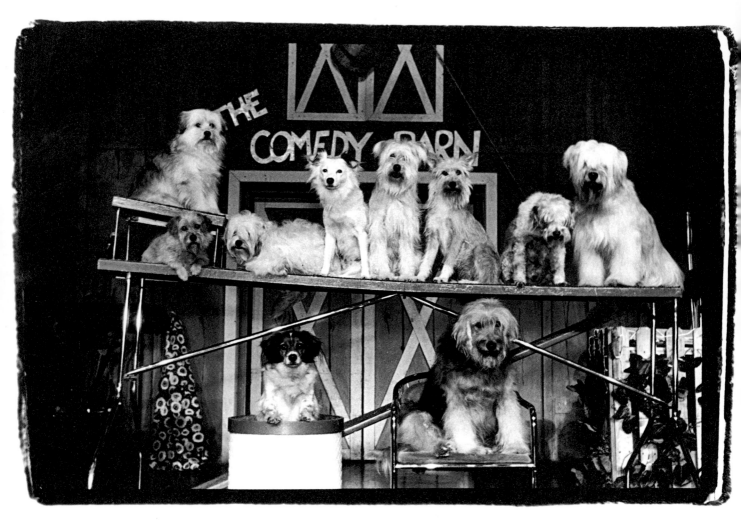

AMAZING MONGRELS

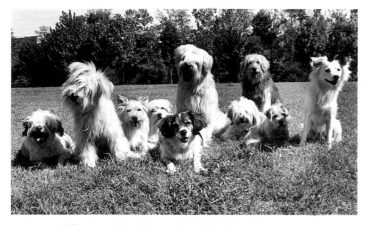

AMAZING MONGRELS AT THE PARK

throughout the entire shoot because the dogs were so funny and entertaining.

The Amazing Mongrels are all adopted dogs that have been trained to perform for audiences nationwide. When I took photographs of their performance (opposite), I used two flashes—one on top of my camera and one on a separate light stand set off to the side of the stage. I used my Nikon N90 and a wide-angle lens so I could show the width of the stage. My camera was set up on a tripod because the dogs were moving quickly and I was planning on taking several rolls of film in the same setting. Certain elements of the performance were repeated so that I could take several frames of the same act just in case I missed it the first time.

The second half of the shoot was conducted outdoors at a local park. Since the dogs were well trained, they stayed seated in the grass together. I used my harmonica to get their attention and, miraculously, they all looked at the camera. The end result was a family-like portrait (above) of ten animated mixed breeds.

NERO AND RILEY

MARLENA AND AIDAN

Two Dogs

Taking a portrait of two dogs together also poses certain challenges (see also pages 25–27). Over the years, I have developed two different approaches to taking multiple-dog portraits. The first is similar to the approach I use when photographing one dog. I place the dogs on a chair, bench, or in the grass. I usually have the owner behind me holding treats. I like to call the dog's name myself because when the owner calls it, the dog turns to look at the owner, not at the camera.

This straightforward technique was implemented with this image of Nero and Riley (opposite). They are seated on a lounge chair. Their owner had dog treats behind my right ear, and I used familiar words and sounds to get them to look at the camera. This digital portrait was taken with my Nikon D200 and an 18–70mm lens.

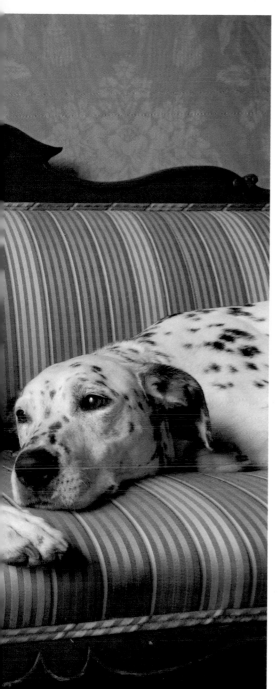

> **Tip: When photograph-ing multiple dogs, use treats and sounds to get their attention. If they do not obey your commands, be patient and wait for them to interact with each other and their environment.**

For the photographs of Marlena and Aidan (page 111) and Coco and Pepper (opposite), I utilized the second approach, which involves positioning the dogs in an area with a clean yet interesting background, then waiting until something unusual happens. In the portrait of Marlena and Aidan, both dogs heard sounds and turned their heads in opposite directions. This image was taken with 400 Tri-X film and a wide-angle lens because I loved the look of their house in the background. With some luck and patience, the second approach can turn into a unique portrait.

The picture of Coco and Pepper was the result of my taking my time and waiting for a moment to happen between the two dogs. Both Coco and Pepper were older dogs who were tired from our photo shoot. They were photographed in a well-lit room sitting on an ornate living room sofa. I took this portrait while they were settling into the sofa and taking a rest. Even though they aren't interacting with each other, their portrait is regal and compelling. This portrait was also taken using my Nikon D200 with a 400 ISO setting.

COCO AND PEPPER

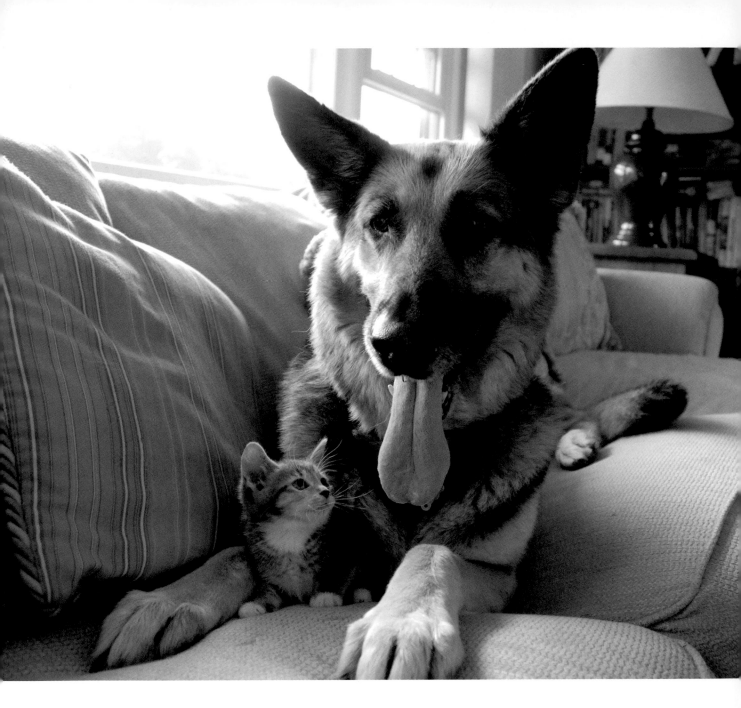

NINA AND KITTEN

Dogs and Cats

It was inevitable that I would eventually photograph cats. In my experience, cats are more difficult to shoot than dogs primarily because of their independent nature. They don't particularly care if you call their name or squeak a toy. Therefore, I had to develop a whole new approach when I began taking pictures of cats.

You have to approach a cat on its own terms. I have never had much luck placing a cat in a particular area and trying to take its portrait. Rather, I ask the owner where the cat's favorite spot is in the house. Usually it is on a bed or a windowsill where the sunlight is strong. Adding a dog into this mix is not easy, but if the dog and cat like each other, it is possible to take a unique and funny portrait. In most cases, it's best to wait until the cat is comfortable and then bring the dog to it.

The technique I have developed for photographing dogs and cats together is the "wait and see what happens" approach. I have learned that no matter how hard you try, you can't force a cat and dog to sit together.

The portrait "Nina and Kitten" (opposite) is a good example of what can result if you observe the interaction between a dog and cat and document their relationship as it unfolds before your eyes. Nina, the German shepherd, and her family were fostering a litter of kittens. The kitten wasn't scared of the big dog, and Nina was fascinated by her. I positioned Nina on the sofa and put the kitten between her paws. Nina was gentle and loving with the kitten. I took this portrait with my Nikon D200 and a wide-angle lens, utilizing available light from a large window.

Tip: When photographing dogs and cats together, it's best to get the cat comfortable first and then bring the dog into the picture.

GISELLE AND STEPHEN

LAUREN AND RILEY

Dogs and Their People

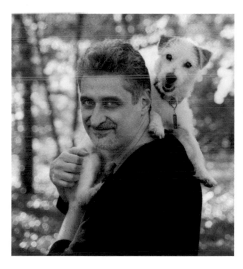

One of the greatest joys of photographing dogs is capturing the love and loyalty they share with their families. When I take portraits of a dog and his owner (see also pages 28–29), I always tell the person to act natural and be affectionate with the dog. At times, I ask the person to look at the camera. However, during the entire portrait session, I am more focused on getting the dog's attention.

This portrait of Giselle and Stephen (opposite) sitting on a rock was taken outdoors with my Nikon F100 and Kodak T-MAX 100 film. It was a beautiful day with lots of light, so low-speed film worked well. I used my telephoto lens and stood a little farther away so my two subjects could interact with each other without

PATRICK AND EARL

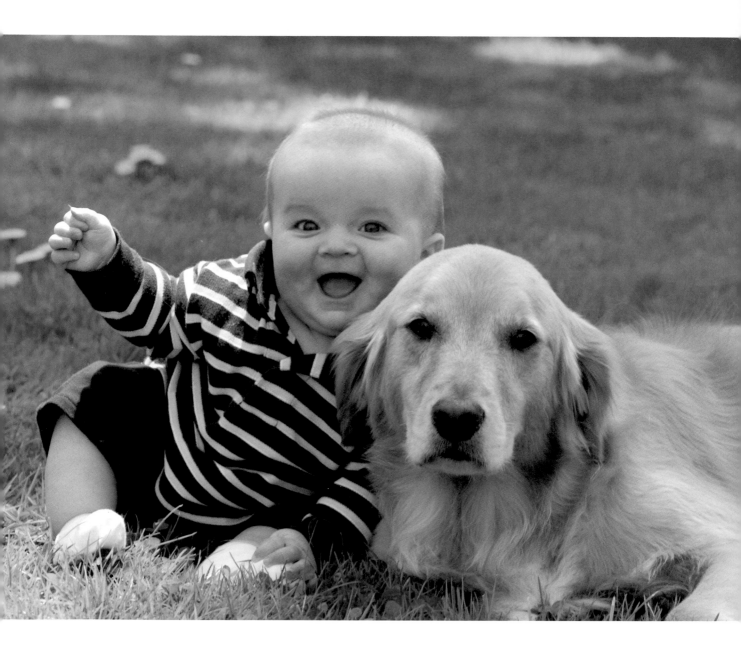

BRAYDEN AND LIBBY

my being right on top of them. This approach allowed them to be more natural and candid. I do not use my wide-angle lens with people and dogs together because it tends to distort people in a way that isn't attractive.

The portrait of Lauren and Riley (page 117, top) was taken with my Nikon D200 and a telephoto lens as well. Lauren posed with Riley outside one of the buildings at her university. My goal was to capture the love and friendship they shared with each other.

The image of Patrick and Earl (page 117, bottom) was taken several years ago for the cover of a magazine. Patrick McDonnell is the creator of the nationally syndicated *Mutts* comic strip, and Earl was his beloved dog and celebrated character in his strip. Earl, a Jack Russell terrier, was willing to sit on Patrick's shoulders. I played my harmonica, and Earl tilted his head when I took this picture. The colorful autumn background added warmth to their playful portrait.

Babies and Dogs

There's nothing cuter than pictures of babies and dogs together. And, fortunately, babies tend to respond to the same tricks as dogs. They may not respond to the harmonica by tilting their head, but they most definitely get a chuckle out of the sound. This is illustrated in the portrait of Brayden and Libby (opposite). Brayden, the baby boy, responded to the harmonica better than Libby did. But Libby was a mellow golden retriever who didn't perk up to most of my sounds. This portrait was taken using my Nikon D200 with a telephoto lens and the camera setting at ISO 400.

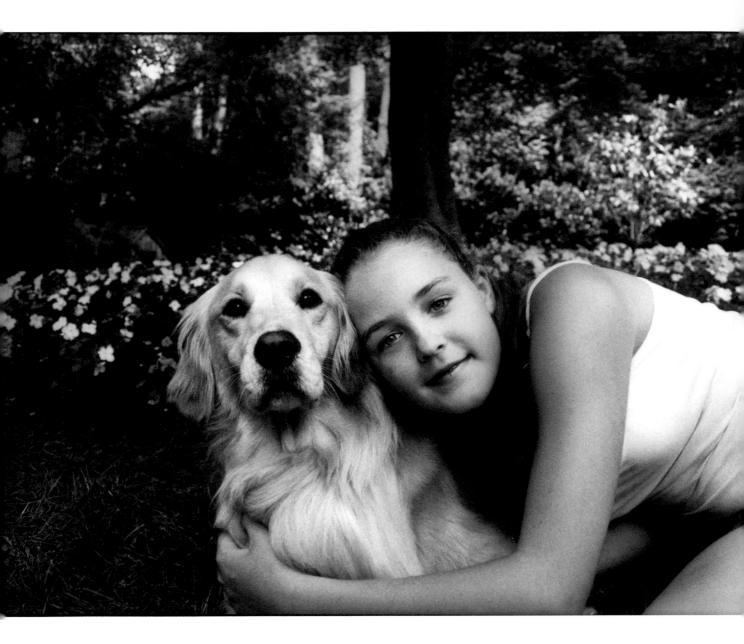

SAMANTHA AND PAIGE

If the baby knows how to sit, it is easiest to position him first. Then, bring the dog over to sit next to the baby. If the baby is not sitting up yet but can hold up his head, put the baby on his stomach. I like to lie down on my stomach to take pictures of babies and dogs together because being at eye-level with them makes for a more engaging portrait.

Kids and Dogs

Most children love having their picture taken, especially if it is with their dog. In my experience, even the most active child will settle down to pose with the family dog.

The key to getting a meaningful child and dog portrait is to make sure they both act as naturally as possible. I ask the child to give the dog kisses and hugs while I am taking pictures. Every now and then, I ask the child to look at the camera and smile. I use the same approaches I always use for the dog (treats, sounds, words) with the hope that he is enjoying the attention from his best friend.

This portrait of Samantha and Paige (opposite) was taken with my Nikon N90 and 400 Tri-X film. Paige, the girl, adored Samantha, so my goal was to capture the love and friendship they shared.

> **Tip:** The key to taking good portraits of dogs with their families is getting the person to act naturally and interact with the dog in a loving manner. Then, sit back and observe their relationship through your lens.

BICHON PUP

Puppies

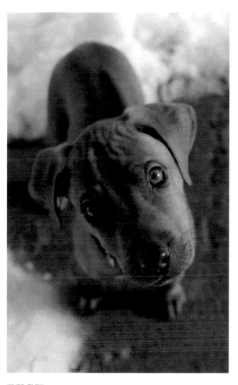

TUCK

Who doesn't like playing with puppies? Well, taking pictures of puppies is basically the same thing. Puppies don't stay still, so you need to pick an area big enough to accommodate their constant movement. You will also need someone to help you pick up the puppies and place them back in your shooting area. As discussed previously, it is easier to place small dogs (puppies included) on objects such as sofas, chairs, benches, and baskets. Find a place from which the puppies can't jump off too easily.

"Bichon Pup" (opposite) was photographed with my Nikon F100 and a wide-angle lens. Only six weeks old, this little guy was fascinated by my camera and looked up at me as I took this picture.

Shooting down at my subject is an approach that I often use when photographing smaller dogs. Shooting down involves standing over your subject and using a wide-angle lens to enhance the dog's head. The body will always look smaller than the head. This portrait of Tuck (left) was taken outdoors on a snowy day. He looked up at me with the most adorable, curious face, and I stood over him and snapped this shot.

Tip: Place puppies on sofas, chairs, benches, baskets, or other places from which they can't jump off too easily.

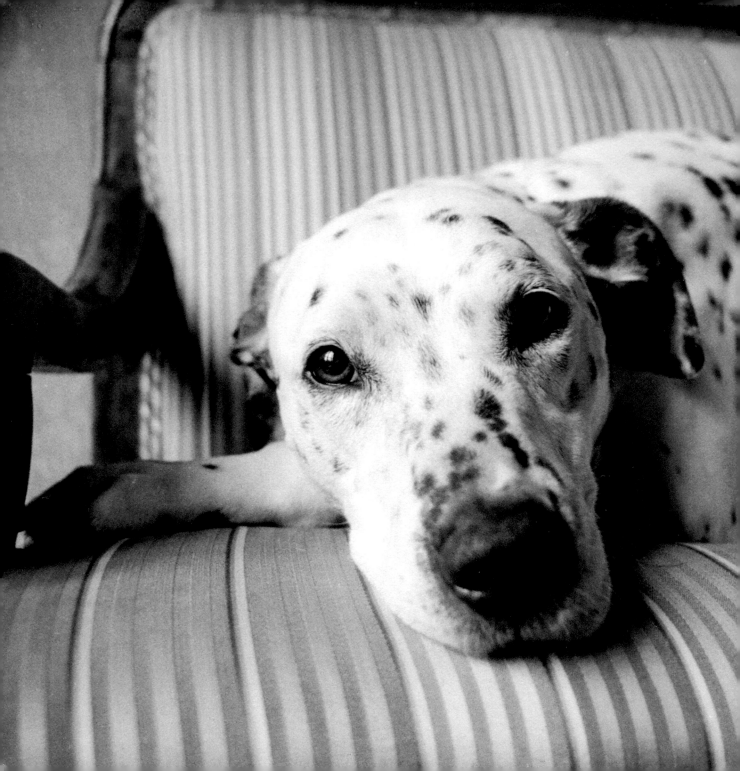

Older Dogs

I have always found older dogs easier to photograph than younger, more active dogs. Because they tire more quickly, they settle down more readily to have their portrait taken. Use this tendency to your advantage.

Pepper, a twelve-year-old Dalmatian, spent most of her photo shoot on a chaise in her living room. She perked up a little when I called her name, and her expression in this portrait (opposite) is sweet and endearing. You get a sense of how relaxed she is. Taken indoors with natural light, this portrait shows that there is still a sparkle in Pepper's eyes.

> **Tip:** Focus your camera on some of the details that make an older dog endearing, such as his graying nose and muzzle or the sparkle in her eyes.

PEPPER

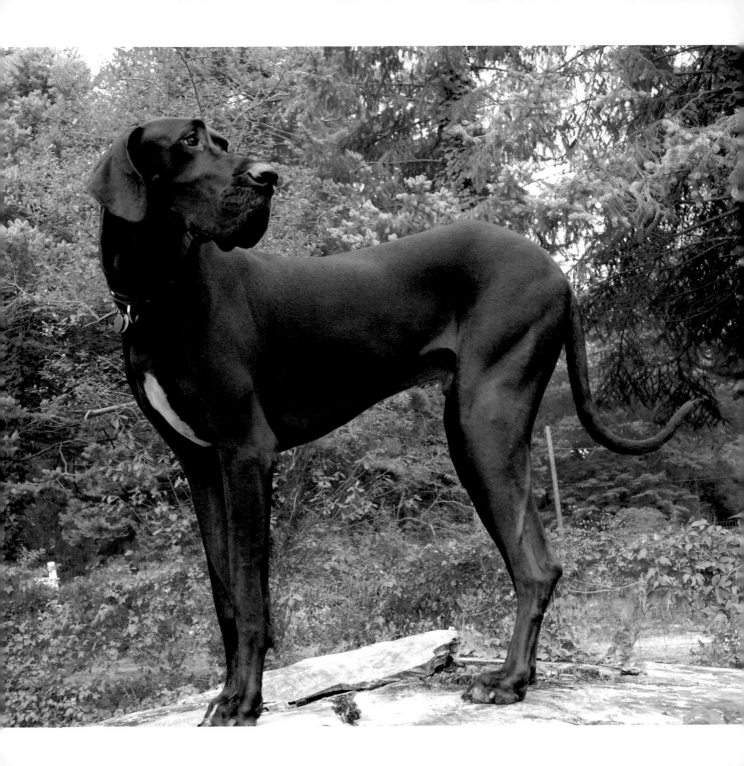

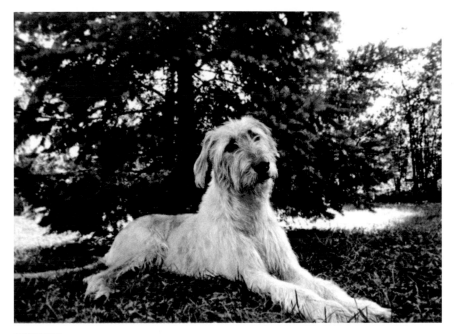

QUINN

Big Dogs

As discussed in other sections of this book, there are some techniques that help when photographing big dogs. Larger dogs need room to move around, and an outdoor shoot will provide you and the dog more freedom and space. Big dogs will not always sit on a chair or bench. They prefer sitting on a larger platform or lying down in the grass or at the beach.

The portrait of Oliver, a Great Dane (opposite), was taken on a large rock in the back of his house. I stood underneath Oliver's long legs and aimed my camera toward the sky. A wide-angle lens helped enhance his stature and length. He was quite mellow during our shoot, as he looked contemplatively to the side. I shot this with my Nikon D200.

> **Tip: Photograph big dogs outdoors where they can move around and have more freedom and space.**

OLIVER

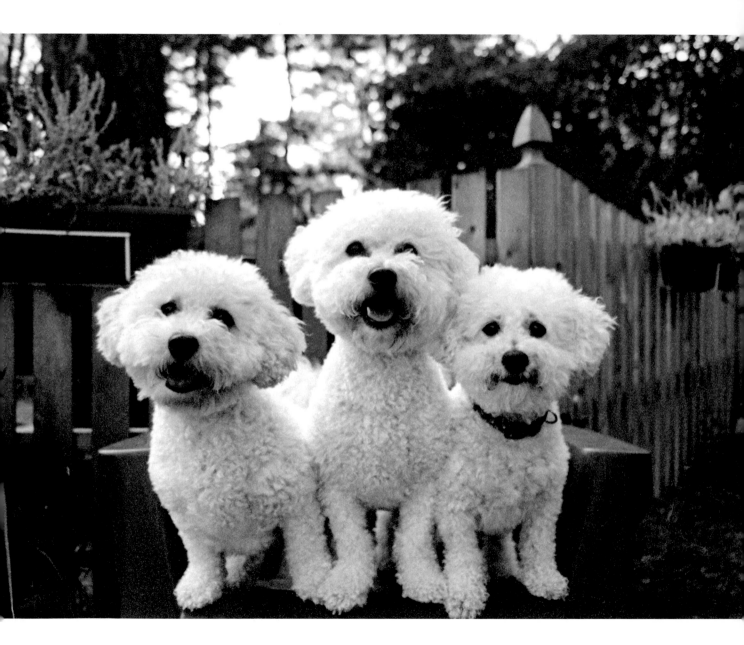

MAX, EMMITT, AND LUCY

Quinn, an Irish wolfhound, was photographed in his back-yard. Using a wide-angle lens, I wanted to capture the length of his legs and body. I gave Quinn lots of love and affection while rolling on the ground with him. Then I sat up and took this picture (page 127). Quinn had a huge presence and an even bigger heart.

Small Dogs

I have found that smaller dogs can be photographed in a wider range of settings than can big dogs. They are more likely to stay put if you place them on a sofa, chair, bench, or other area where they can't run away from you. You may want to try using props, such as buckets and baskets, when photographing small dogs.

This trio of dogs Max, Emmitt, and Lucy—sat in a big green Adirondack chair for their portrait (opposite). They were animated and outgoing and loved the sound of my harmonica. They're practically laughing in this picture.

Tip: Placing small dogs on a bench or in a bucket creates a fun backdrop for your portrait. Props also keep dogs from running out of your picture.

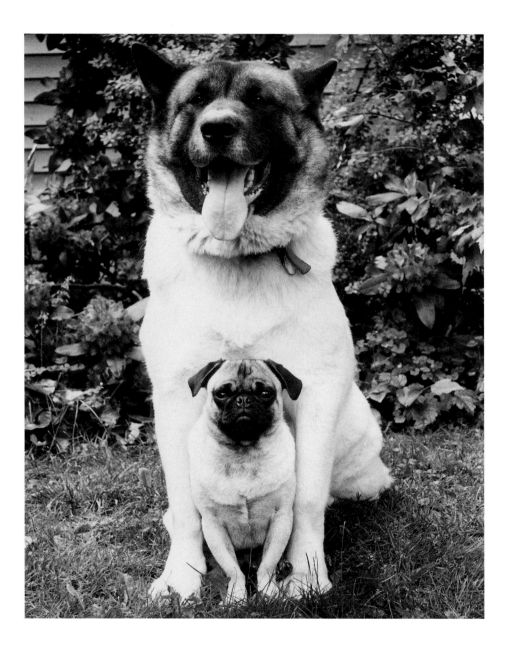

SAMSON AND BOSLEY

Big and Small Dogs

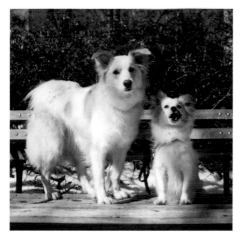

SOPHIE AND HOUDINI

Photographing big and small dogs together can be hilarious and fun. You will want to set up the big dog first. If he will sit and stay, you can then pick up the smaller dog and put him either next to or in front of the bigger dog.

This approach worked well with Samson and Bosley (opposite). Samson was fairly obedient and sat for me right away. Bosley was positioned in front of him. I stood quite close to them and used my wide-angle lens so I could show their full bodies. We used a treat held up to my right ear to get Samson to stay still and high pitched sounds to get Bosley's attention. It was amazing that they stayed in this position long enough for me to get the shot. Eventually, Bosley got tired and left the scene of the shoot. Samson decided he was tired too and took off down the street!

The portrait of Sophie and Houdini (left) was taken for the annual ASPCA calendar. These two had the exact same colorings and markings, but one dog was large and one was small. They were photographed on a park bench on a snowy day. Both dogs' leashes were draped behind them. Using my Nikon F100 and a wide-angle lens, I used my harmonica and high-pitched noises to garner their attention. Sophie and Houdini made a great pair.

Tip: Get the larger dog set up first and then place the smaller dog in front or next to the larger one. Use every trick (treats, sounds, words) to get them to look at the camera.

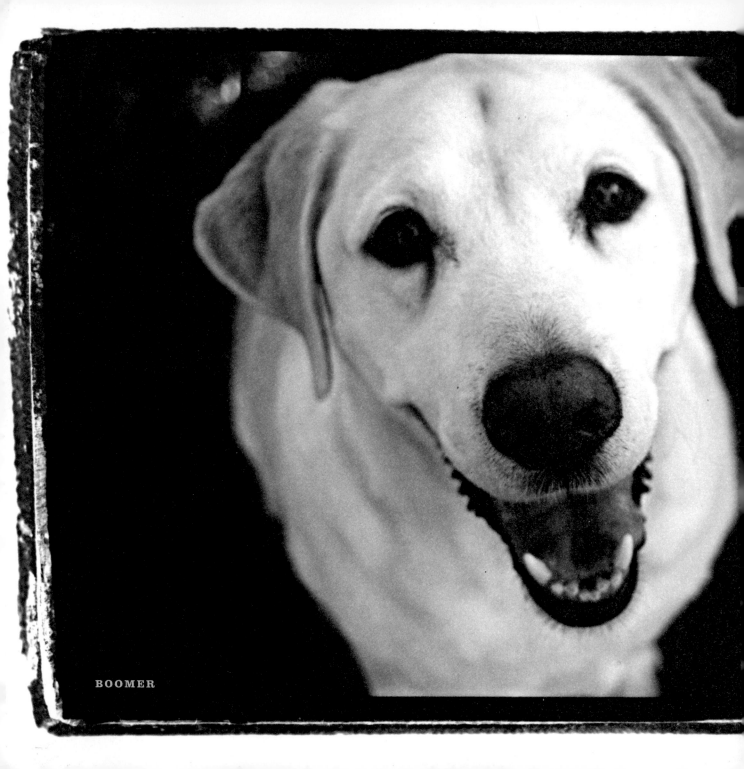

BOOMER